ELLON

A PHOTOGRAPHIC JOURNEY

Ellon & District Historical Society

AMBERLEY PUBLISHING

Acknowledgements

The Society would like to thank all of those who shared their photographic memories. We have more than 800 images on the database and inevitably had to make a selection. The names of contributors are listed below:

Aberdeenshire Library and
 Information Service
Ricky Argo
Mary Burnett
Alan & Elizabeth Cameron
Margaret Cantlay
Valerie Campbell
Maggie Cheyne
Sally Couzin
Fred Crawford
Gladys Davidson
Jocelyn Davidson
Ron Davidson
Doreen Davidson
Morag Doak
Betty Duguid
Brenda Duncan
Rena Duncan
David Ellis
Peter Elrick

Charles & Mabel Esson
May Forbes
Sybil Fowler
Leonard Garland
Jim Gauld
Fiona Grant
Lindsay Halliday
Hazel Howie
Elsie Ironside
George Ironside
Charles Johnston
Lorna Keith
Margaret Matthews
Susan McGowan
Dave McGregor
Alfie McRae
Brian Milne
Moira Milne
Margaret Moir
Ronnie Mortimer

Sheila Noble
Frank Paterson
Sandy Paterson
David Reid
Royal British Legon Ellon
Peter Ritchie
Andy & Dorothy Robertson
Agnes Stuart
Norma & John Stuart
Fred Tadhunter
Esther Tawse
Michael Taylor
Margaret Thom
Maureen Thomson
Evelyn Tocher
The late Douglas Walker
Annie Watson
Gladys Webster
Brian Wilkins

First published 2012

Amberley Publishing
The Hill, Stroud
Gloucestershire, GL5 4EP
www.amberley-books.com

Copyright © Ellon & District Historical Society,
2012

The right of Ellon & District Historical Society to
be identified as the Author of this work has been
asserted in accordance with the Copyrights, Designs
and Patents Act 1988.

ISBN 978 1 4456 0841 9

British Library Cataloguing in Publication Data.
A catalogue record for this book is available from
the British Library.

Typeset in 9.5pt on 12pt Celeste.
Typesetting by Amberley Publishing.
Printed in the UK.

Introduction

The town of Ellon in Aberdeenshire sits astride the River Ythan at the first point above its estuary where a fording was possible. There are several islands in the river nearby and it is thought that the name derives from the Gaelic *eilean*, meaning island. As early as 400 BC, Ellon was the principal Pictish settlement and was the main crossing place for travellers from the south heading for Buchan. In the early middle ages it served as the meeting place for the Celtic 'Mormaers' or rulers of Buchan, and later on the Norman Lords of Buchan (the Comyns) held court at Moot Hill by the river.

The town gained in size and importance through the centuries and the building of a bridge in the eighteenth century followed by a more modern one in the 1940s helped that expansion. A coaching inn, other hotels, the coming of the railway, the increase and modernisation of farming, the introduction of light industry and latterly the discovery of oil in the North Sea have all contributed to the creation of the present town.

This growing community has reacted to the changing economic and social environment by adapting old customs and practices and by creating new businesses and activities. Since the end of the nineteenth century many of these changes have been recorded photographically, and the Society has formed a collection of these pictures, which were donated by town residents. Using this collection, this book attempts to display some of the places, events and, above all, some of the people involved in the town's development. Enjoy travelling on this photographic journey through these aspects of Ellon life in recent decades.

CHAPTER 1

Churches

Records show that the parish church in Ellon was founded in 1265 as part of the Diocese of Deer. At the time of the Reformation in the 1560s the church became Protestant. The existing parish kirk was built in 1777. The Protestant Church suffered a series of secessions, culminating in the formation of the United Presbyterian Church. The Disruption of The Church of Scotland in 1843 led to the formation of the Free Church. The United Presbyterian Church and the Free Church combined to form the United Free Church in 1905. The United Free Church and the Church of Scotland united in 1929.

In 1934 premises were made available for a Roman Catholic chapel to celebrate Mass in a permanent location for the first time since the Reformation. This building was used until the current Roman Catholic church was opened in 1991.

St Mary's, the Episcopalian church, although suffering setbacks in the seventeenth and eighteenth centuries, survived and moved to its present location in 1871.

All of these churches contributed to the many community clubs and associations that are present in Ellon today.

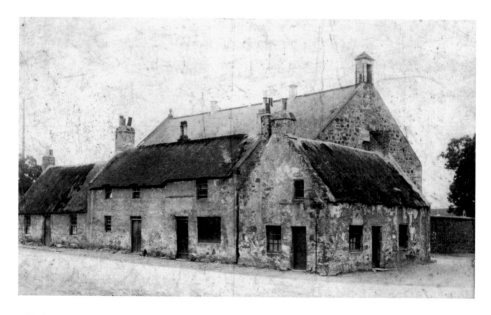

Old thatched buildings in the Square with the parish church at the rear, 1900s.

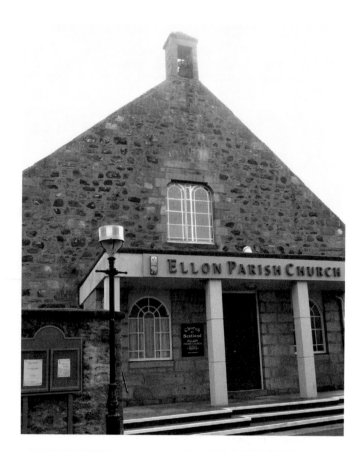

Right: Ellon parish church, main entrance.

Below: The Annand Memorial in Ellon kirkyard is all that remains of the medieval church, which was replaced in 1777 by the present building.

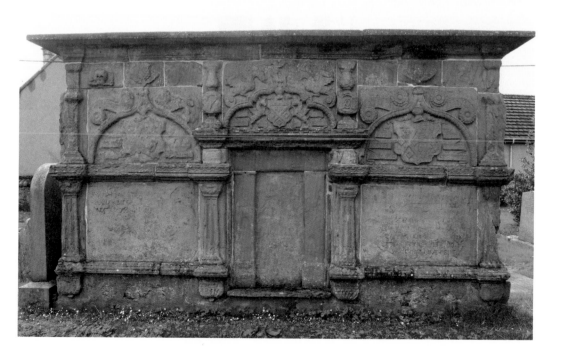

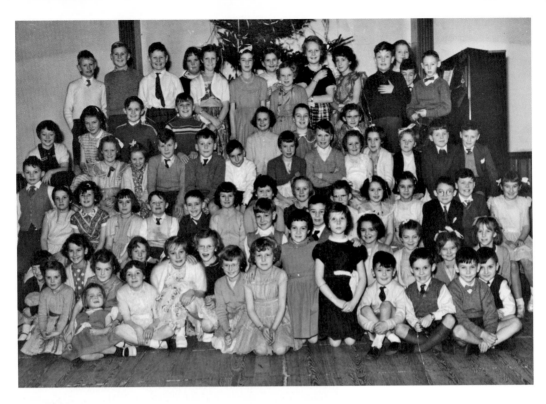

Above: Ellon parish church Sunday School party, 1960.

Below: Ellon parish church guild 1986, flanked by Revd Mike Erskine on the left and Revd Matthew Rodger on the right.

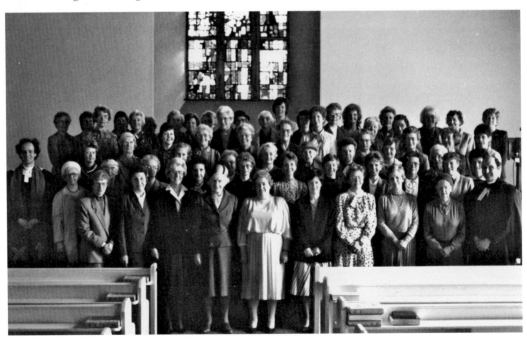

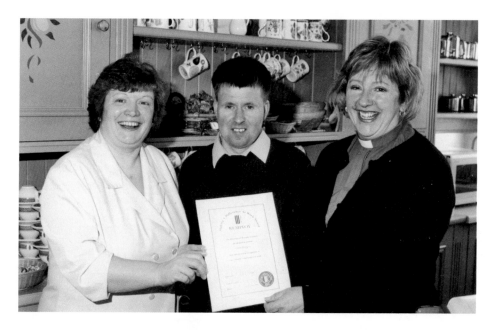

Above: Colin Burgess receiving a Remploy Certificate from Iris Murray and Revd Eleanor Macalister, in 2001, for his valuable work at Ellon Kirk Centre coffee shop.

Below: Ellon parish church Young Womens' Group 20th anniversary, 2001. Frrom left to right, back row: Morag Doak, Margaret Lafferty, Valerie Campbell, Mary Morrison, Anne Thow, Eleanor Macalister, Lynne Paterson. Front Row: Alison Young, Elaine Aderaye.

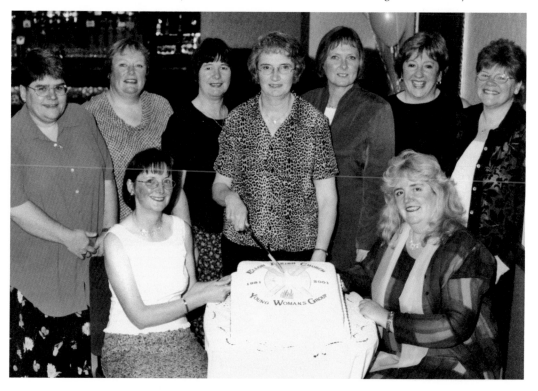

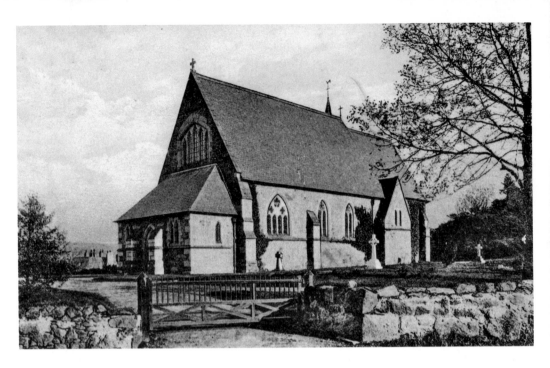

Above: St Mary's on the Rock, 1917.

Below: St Mary's on the Rock and Manse from Ythan Terrace in the 1900s.

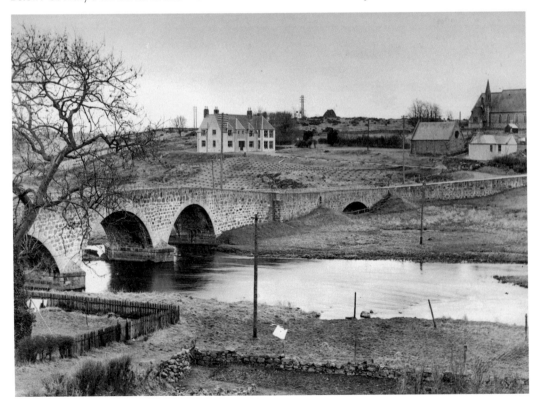

Above: St Mary's on the Rock Rectory, about 1900.

Below left: Manse of St Mary's parish church, about 1900

Below right: Gerald Stranraer-Mull welcoming Bishop Hamish Jamieson from Western Australia to St Mary's on the Rock, 2002.

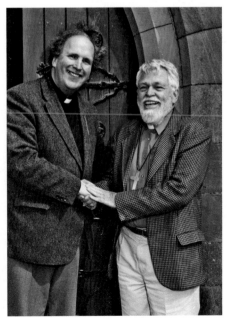

Left: Old Catholic church, founded by Victoria Ingrams, daughter of Sir James and Lady Reid. Victoria, who converted to Catholicism after working in a London hospital, decided that there should be a Catholic church in Ellon. The original Catholic church (now Ellon Parish church) ceased to be Catholic at the Reformation in 1560. This church was in the coach-house of her parents' home, 'The Chestnuts' and stood on the site of the present Catholic church in Union Street.

Below: This church replaced the older Catholic church and was opened in the 1990s.

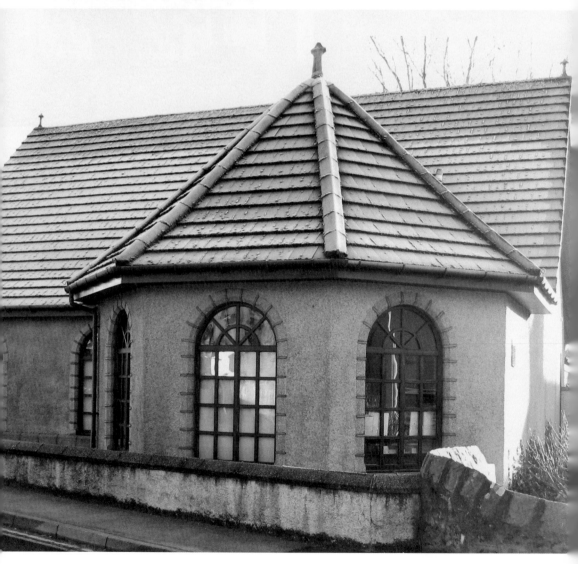

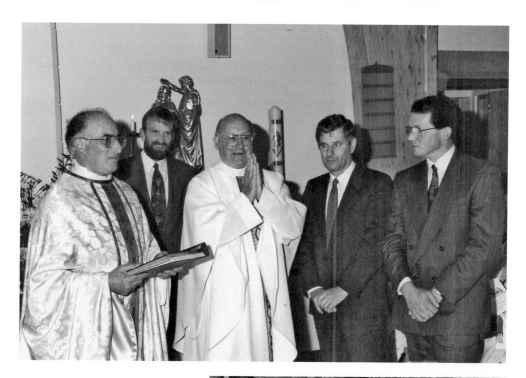

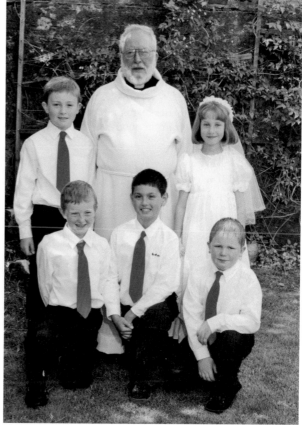

Above: Dedication of the new Roman Catholic chapel in 1992. From left to right: Bishop Mario Conti, Michael Taylor (Architect), Father Myles Lovell, Jim Crawford (Ellon Plant Hire), Stephen Burnett (Burnett Building Services).

Right: Father Raymond Coyle at the confirmation of Ben Gilroy, Matthew Holland, James Collins, Matthew Campbell and Mhairi-Anne Fraser in 2000.

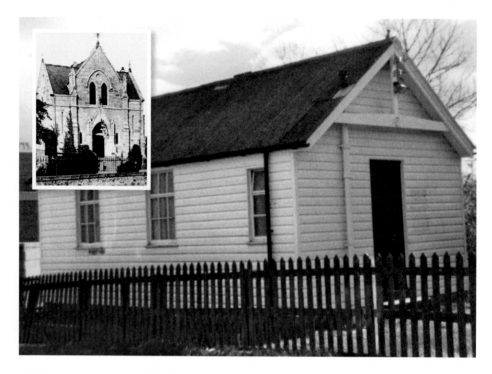

Above: The Pentecostal church in Union Lane was previously used by the Plymouth Brethren.

Inset: St Andrew's church, originally Ellon United Presbyterian church. It joined with Ellon Free Church South and then with the Church of Scotland. In the 1950s it became a cinema, and in the 1960s a furniture showroom.

Below: County cinema in 1955. It was converted from the former United Free church. It was knocked down in the 1990s and replaced with housing (Whisky Brae).

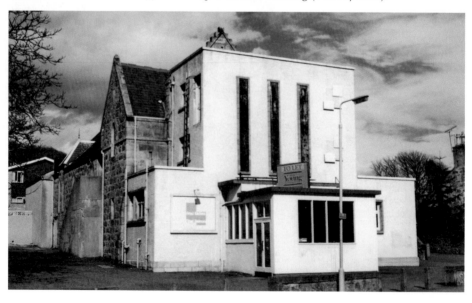

CHAPTER 2

Education

There is a reference to 'scholars in Ellon' in the twelfth century *Book of Deer* but the place of that scholarship is unknown. The oldest building in the town is the Old Schools, which was close to and associated with the parish church and dates from the sixteenth century.

In the mid-nineteenth century, as well as the Old Schools there was a girls' school run by the Church of Scotland, a Free Church school, a school associated with the Episcopal Church and a school in the Tolbooth. After the 1872 Education (Scotland) Act, a new school, the Public School, was built on New Deer Road. In 1951 the Public School became Ellon Academy, and in 1962 the primary section became Ellon Primary School. In the 1970s Auchterellon and Meiklemill Primary Schools were established. In 1979 a new building was added to Ellon Academy and incorporated a community centre.

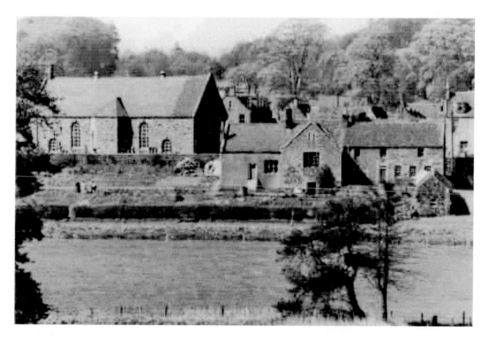

The Old Schools (the oldest building in Ellon), where, among others, Sir James Reid and Sir James McDonald had their early education. After the Education (Scotland) Act of 1872, which brought in universal free compulsory education, this school ceased to function.

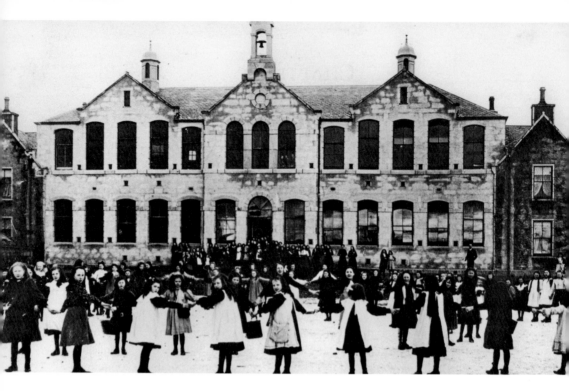

Above: Ellon Public School. This was the only state school in Ellon until the 1950s and had both primary and secondary departments.

Below: Ellon School Group, 1929.

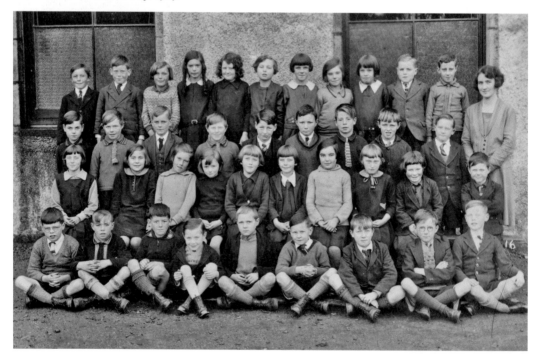

14

Right: Eric Slater, Rector of Ellon Academy 1971–1981

Below leftt: Alan Cameron, Rector of Ellon Academy 1981–1996.

Below right: Brian Wilkins, Rector of Ellon Academy 1996–2007.

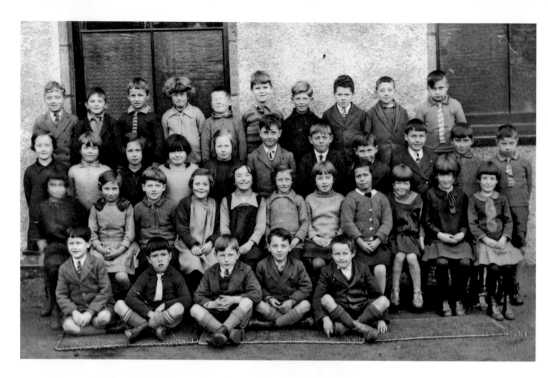

Above: Children aged seven and eight in primary classes of Ellon School, late 1920s. From left to right, back row: Freddie Dixon, ? Legatt , Gilbert Cowe, ? Allan, Gordon Slessor, ? McLeod, Maxie Ironside, Sandy Paul, ? Coutts, ? Moir. Third row: -?- , -?- , ? Aitken, ? Moir, ? Johnston, Robbie Burgess, Arthur Johnston, George Alexander, -?- , -?- , ? Moir. Second row: ? Elrick, -?- , -?- , -?- , -?- , -?- , Bunty Soutar, -?- , Nora Minty, Moira Gillan, Isobel Oliphant. Front row: John Wilkie, ? Elrick, Douglas Walker, Freddie Brown, ? Rennie.

Below: Ellon Public School in the late 1920s. On the back row, the second boy from the right is Andy Robertson. The teachers are Miss Mackie and Miss Oglivie.

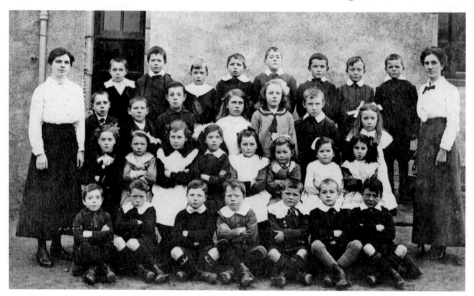

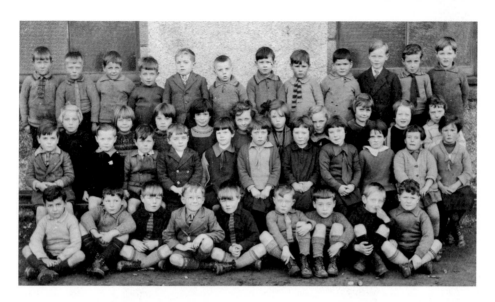

Above: Primary 1 intake at Ellon School, 1927. Back row: -?- , -?- , -?- , -?- , Douglas Paul , -?- , ? Mutch, -?-, -?- , Frank Duguid, Gordon Gibson. Third row: Margaret Low, Kathy Davidson (Downie), Ruthie Souter, Margaret Davidson, Nora Cowie, -?- , Julia Clubb, Jean Ironside, May Forbes, Agnes Smith. Third row: Bobby McLeod, David McGill, Alex Mortimer, Gordon Smith, -?- , Annie Kirton, Agnes Hardie, Margaret Matthew, ? Hunter, Betty Shinnie, -?- . Front row: Francis Strathdee, ? Buchan, ? Massie, Charlie White, ? Massie, ? Chalmers, -?- , Walter Hardie, -?-.

Below: Primary 3 in the late 1930s, having an outdoor lesson in the Caroline's Well Woods. Alfie McRae is the boy sitting front left. The boy third from the right, behind the girls, is Peter Davidson. Two behind him is Tom Patey, who went on to be a world-class mountaineer.

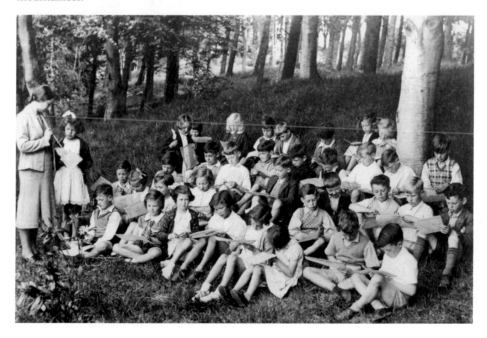

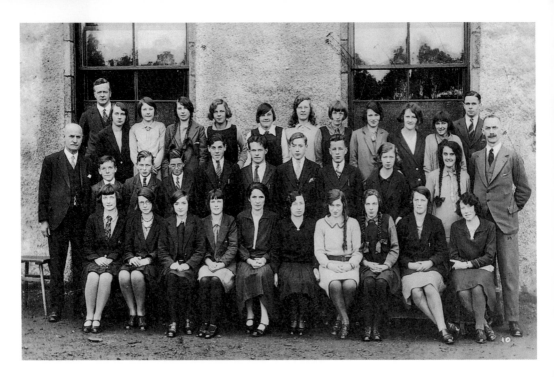

Above: Ellon School staff, 1930s.

Below: Ellon School class, 1939/40.

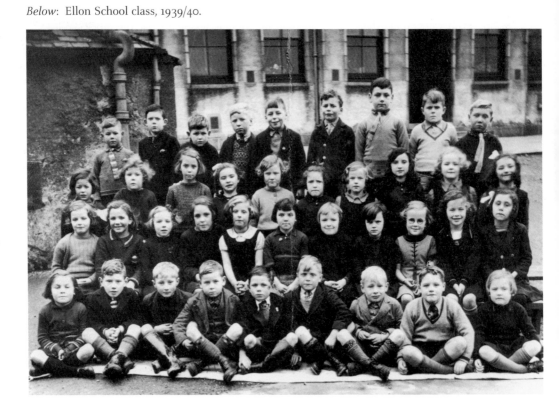

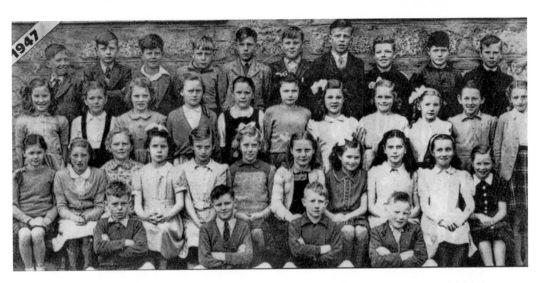

Above: Ellon School primary pupils, 1947.

Below: Schoolboys planting potatoes in the school garden in 1947. This activity was organised by teacher John Cordiner. Pupils, from let to right: Frank Paterson, Eddie McDonald, Johnny Lawrence, George Duncan, Eddie Morrison.

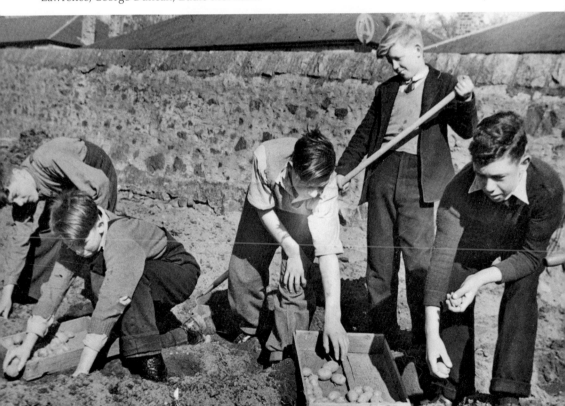

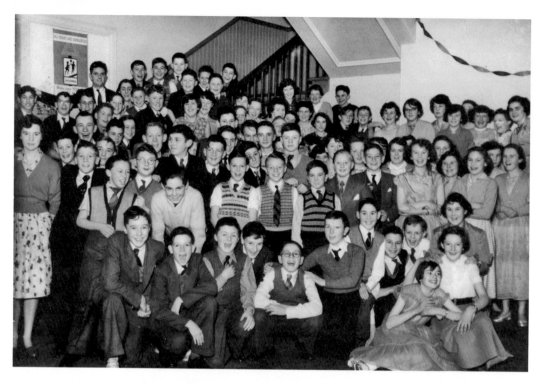

Above: Ellon Academy Christmas party, 1950s.

Below: Ellon Academy class, 1959.

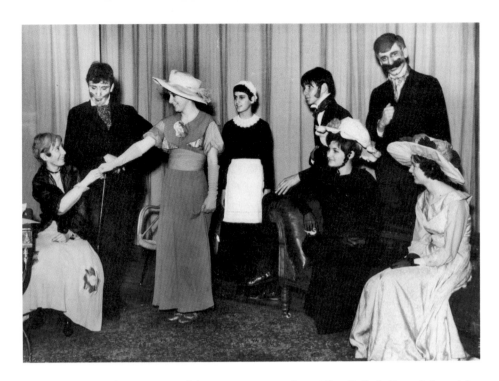

Above: Ellon Academy Drama Club, 1959, in a scene from *Eliza Dolittle*. From left to right: Anne Middleton, Laurenzo Furno, Wilma Mitchell, Margaret Stephen, Sandy Parker, Anne Wyness, James Gibb, Valerie Campbell.

Below: Ellon Primary class, 1971. The teacher is Heather Black.

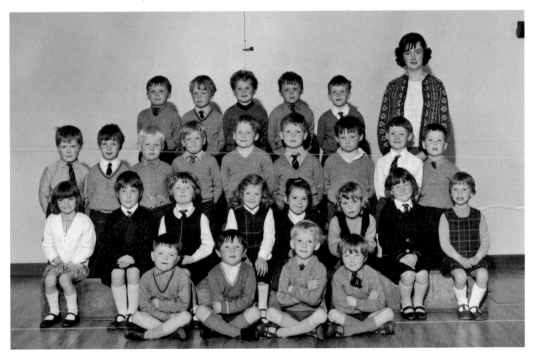

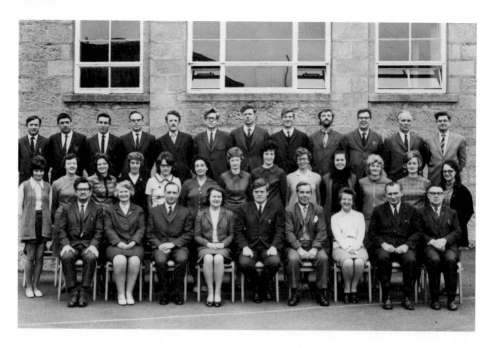

Above: The staff of Ellon Academy, 1971. From left to right, back row: C. Connor, L. Scott, J. Davidson, F. Duguid, I. Stewart, F. Crawford, R. McCallum, R. McKenzie, E. Swann, L. Johnston, A. Bolland, B. Milne. Middle row: P. Ozanne, Mrs Rae, Mrs Atkinson, E. Milne, W. Cruickshank, J. Silver, G. Chew, L. Marioni, B. Mollison, I. Duncan, M. Paing, E. Burr, W. McDonald. Front row: J. Cooper, D. McLeod, S. Brown, G. Taylor, E. Slater, D. Low, H. Curry, A. Parker, J. Cordiner.

Below: Ellon Academy Orchestra, 1978.

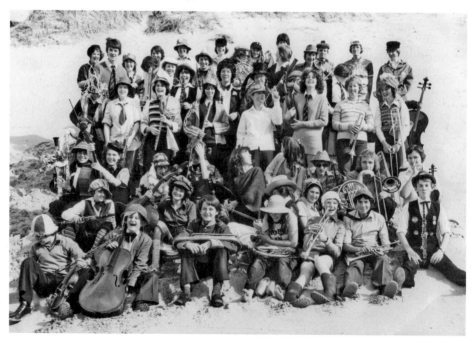

Above: Ellon Primary School, 1981.

Below: Ellon Academy Orchestra, Choir and Band, May 2001.

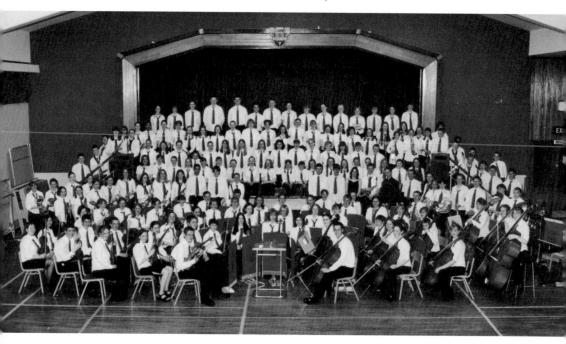

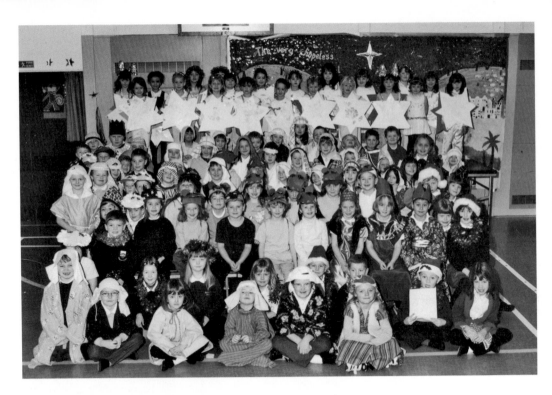

Above: Meiklemill Primary School Nativity play, December 2001.

Below: Staff at Auchterellon School in festive outfits, 1990s. From left to right, back row: Dorothy Duncan, Dorothy Mckay, Lynda Page, Sheila Craggs. Front row: Helen Mann , Leah Davidson, Margaret Middleton.

Above: Auchterellon Primary School end-of-term concert, March 2002.

Below: Peter Crampton of Ellon 'Save the Children' Committee receives a cheque from Ellon Primary School pupils in the 1990s. Peter was part of the Ellon Branch that raised £140,000 over twenty years.

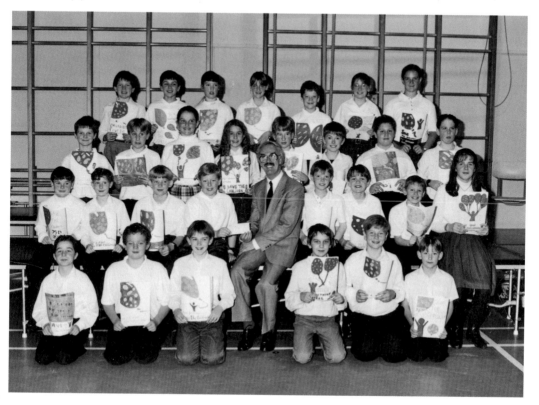

CHAPTER 3

Farming

Ellon is situated at the southern limit of the Buchan Plain, which is the second largest agricultural area in the UK (East Anglia being the largest). Right up to medieval times the plain was a mixture of forest and scrub land, with conifers, gorse and heather predominating. Much backbreaking work was undertaken in the seventeenth and eighteenth centuries to clear the land in order to grow crops and husband animals. This effort proved successful and ultimately the entire area was given over to farming, both arable and livestock.

In the nineteenth century larger farms were created. They employed many men via the 'feein'' system. This meant that men were engaged for short periods – a few months, depending upon the season – and were often housed in 'fermtouns' or 'cottouns'. With the advent of mechanisation in the 1930s, men and working animals were replaced by increasingly sophisticated machinery. This had the effect of people leaving the land to seek employment in towns.

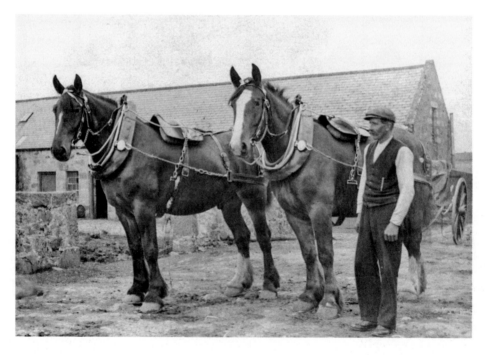

Mill of Birness: George Melvin and team, 1900s.

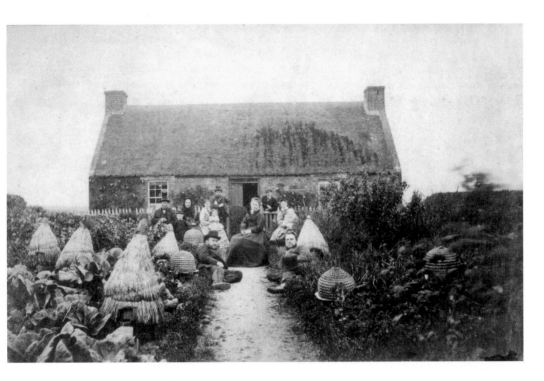

Above: The Marr family with their beehives at Auchmacoy, 1902.

Below: Milltown of Birness Farm, 1900s. George Melvin is on the right.

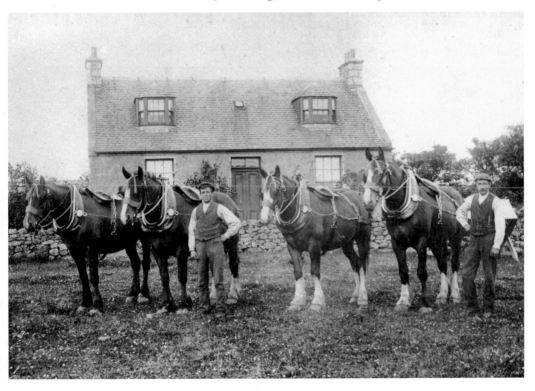

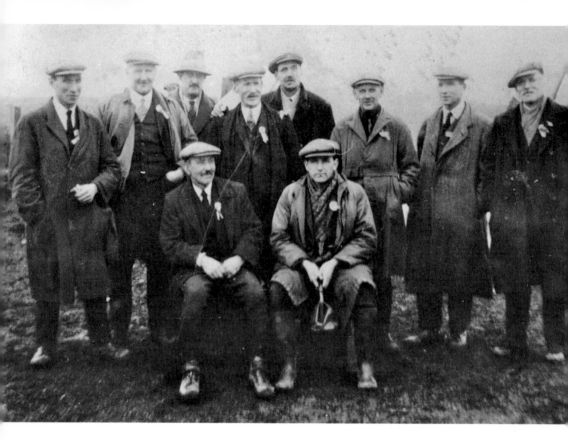

Above: A ploughing match group at Knapps Leask, Slains, 1923/24.

Below: Horsemen at Cromleybank Farm, 1920s.

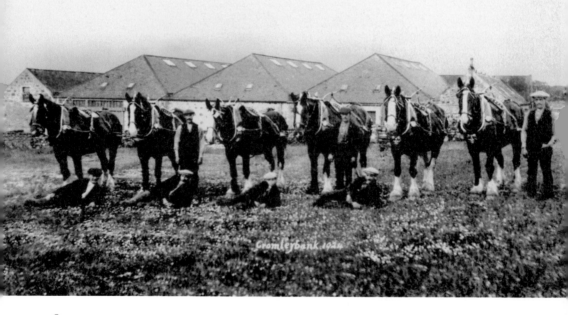

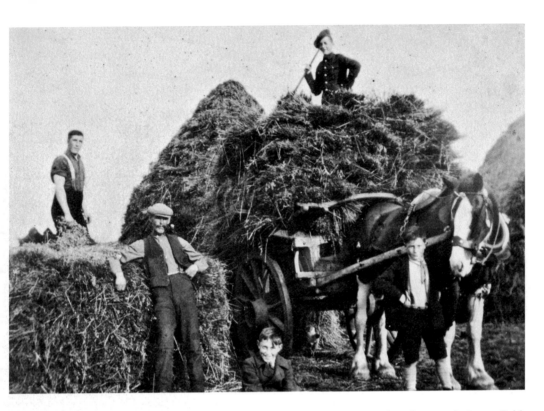

Above: Jim Robertson harvesting with sons, Jim, Sammy, Wullie, and Andy at Little Broomfield, 1940s.

Below: Davie Low harvesting at Broomfield, 1930s.

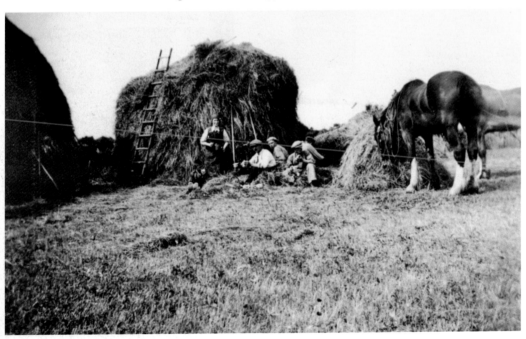

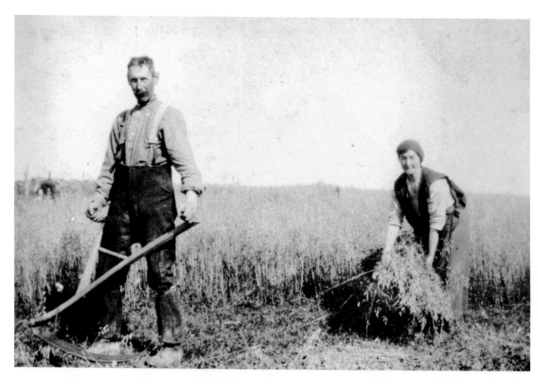

Above: Jim Robertson and his wife Elizabeth scything a crop at Little Broomfield, 1930s.

Below left: Davie Low taking sacks from the granary at Broomfield, 1930s.

Below right: Andy Robertson with his first sheep at Little Broomfield, 1930s.

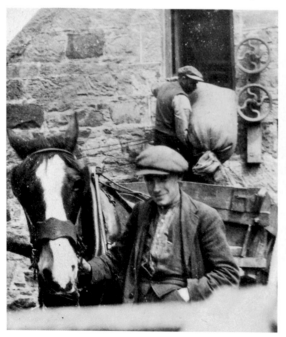

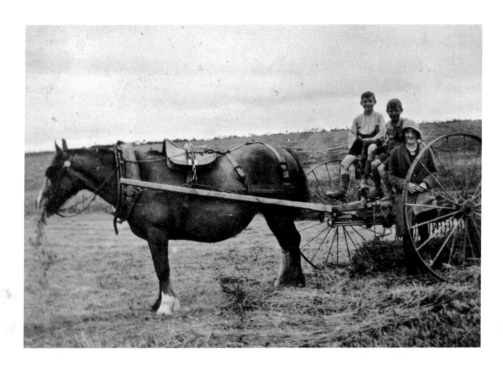

Above: Andy, Wullie and Anna Robertson on the farm cart, 1930s.

Below: Jim Robertson with his son Andy at Little Broomfield, 1930s.

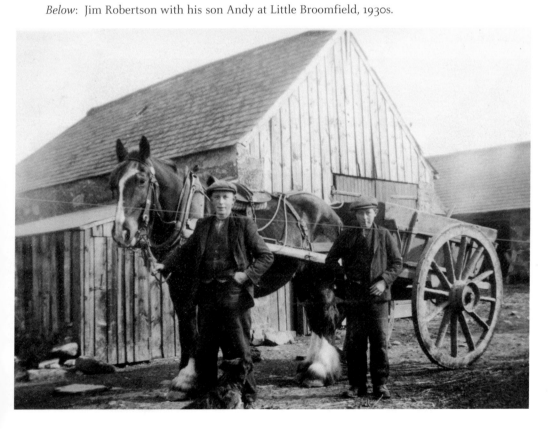

Above: Sandy and Campbell Davidson feeding the lambs at Knockothie in the 1930s.

Below: Alex Davidson, Knockothie Farm, with the milk-churn cart, 1920s.

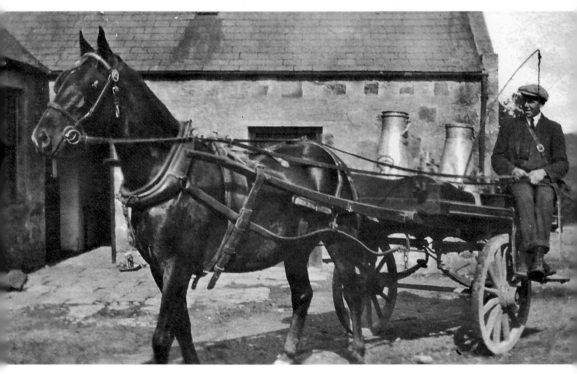

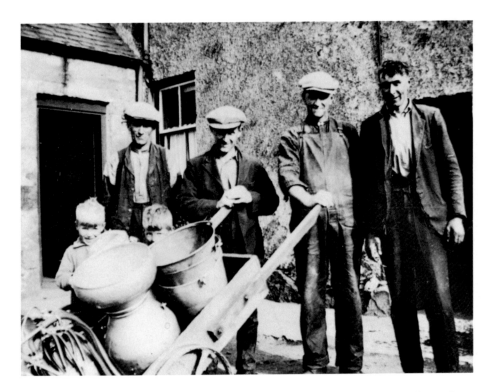

Above: Milk churns at Knockothie Farm. The two boys are Sandy and Campbell Davidson, 1930s.

Below: Harvesting in the 1950s.

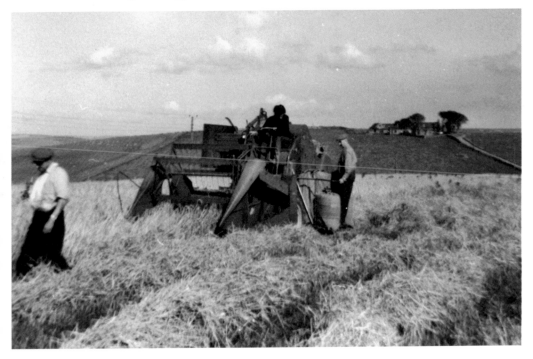

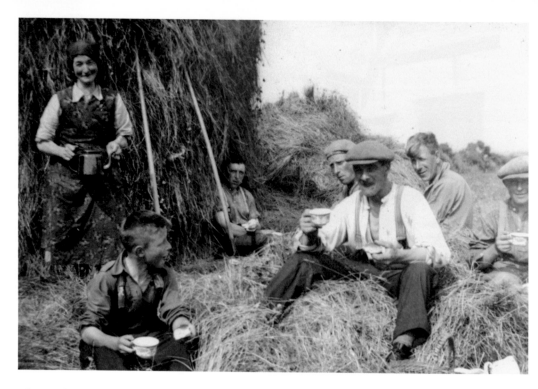

Above: Fly cup time at Broomfield, 1940s.

Below: Harvest home. Andy, with sons Drew and Kenny, building a ruck in the stackyard at Little Broomfield, 1960s.

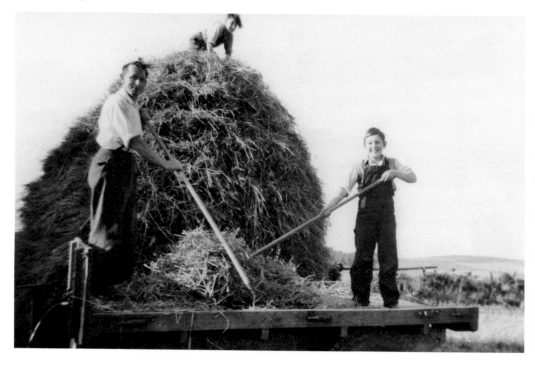

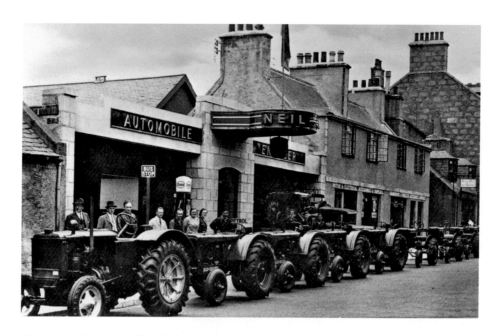

Above: A delivery of Allis Chalmers tractors in 1939. Neil Ross realised that because many of the farmworkers would be away on active service, farmers would need more mechanised equipment. From left: Neil Ross, John Willox, Charlie Dickson, George Low, Tommy Thomson, Miss Collie, May Forbes, Bill Cruickshank.

Below: Cutting the crop. Drew Robertson driving with brother Kenny at the binder at Little Broomfield, 1960s.

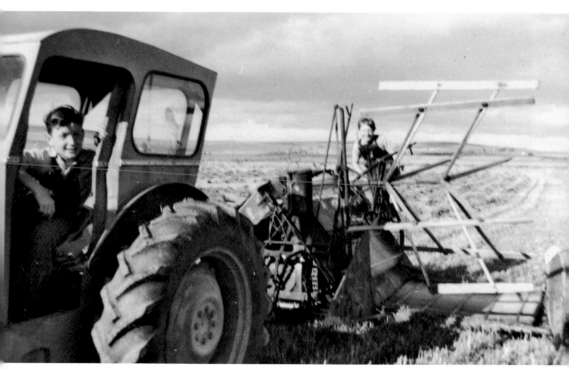

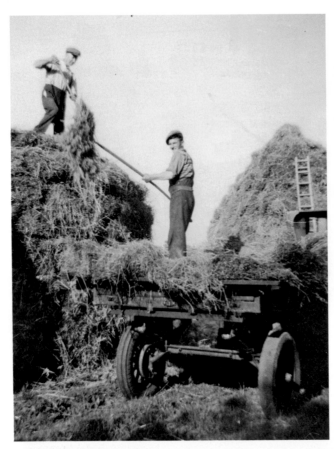

Left: Building a hay ruck at Leys of Auchmacoy. John Milne on the top is being helped by Ronnie Mortimer on the cart.

Below: Dave McGregor (vet), with Ellon firemen and RSPCA officers, rescuing a bullock from the rocks at Collieston in 1994.

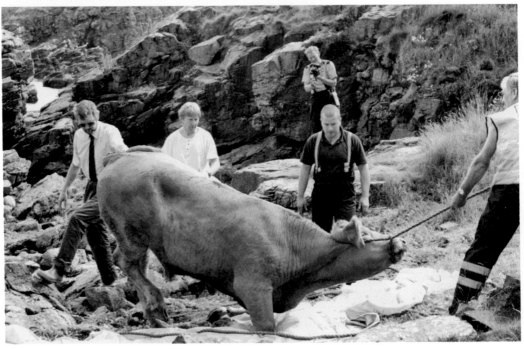

CHAPTER 4

Businesses

With farming the main industry in the area, it is hardly surprising that other, related businesses also emerged. Farriers and smithies were particularly in demand. Owners did not expect a draught horse to walk more than around 4 miles to be shod, so there tended to be at least one farrier within that distance of every farm. As travel became more commonplace many farriers diversified and became blacksmiths, making and mending metalwork for carts and carriages, as well as for farm implements.

Water-powered mills were also present to handle grain produced by the farmers.

With the coming of mechanisation garages started to appear. Tractors of ever-increasing size and more complex farm machinery came into use.

The first large factory to open in the town was the Boot & Shoe Factory, which was built in 1892 and at that time employed seventy members of staff.

For some centuries there had been a market in the town. Shops also opened, catering for residents' needs. These shops have multiplied and Ellon now has a variety of retail outlets.

Since the 1970s oil services companies, working initially for developers in the North Sea, but more recently for oil companies worldwide, have made a home in the town.

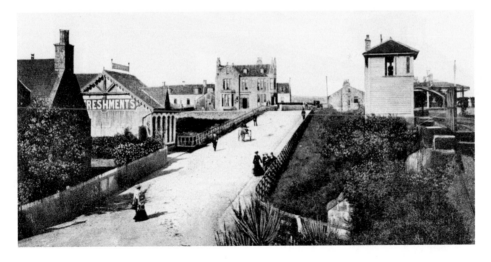

Station Brae, 1900s, with the Station buffet on the left and the railway signal box on the right. The Station Hotel is in the centre.

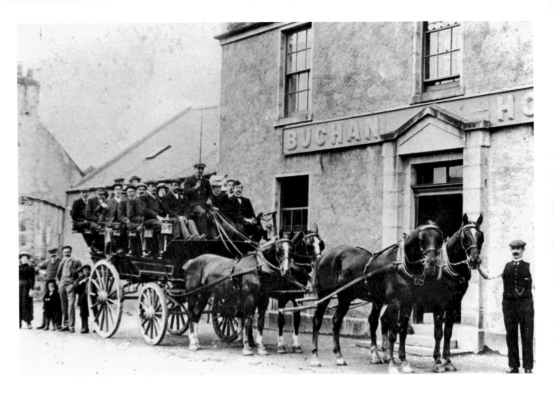

Above: A charabanc outside the Buchan Hotel in the early 1900s.

Below: The Buchan Hotel, in the early 1900s.

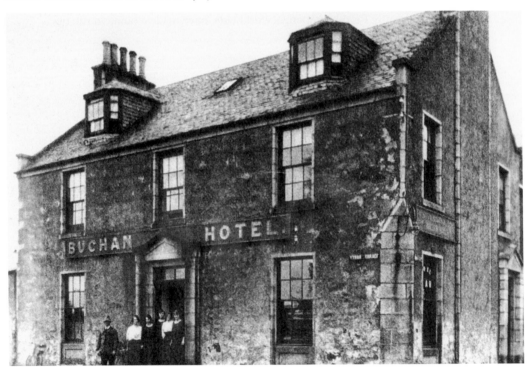

Above: The New Inn Hotel, 1900s.

Below: The original Craighall Inn on the corner of Riverside Road and South Road, 1900s.

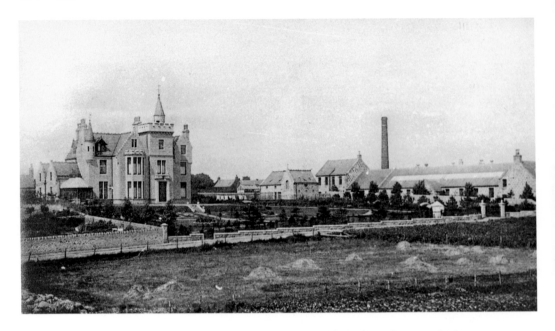

Above: Auchtercrag House (originally called Gareta Hill), and the boot factory. The house was built on Commercial Road in 1896 and the factory was built in 1892. Both were owned by William (Bulldog) Smith.

Below: Neil Ross Cycle Shop (now Casa Salvatore), Station Road, in 1919.

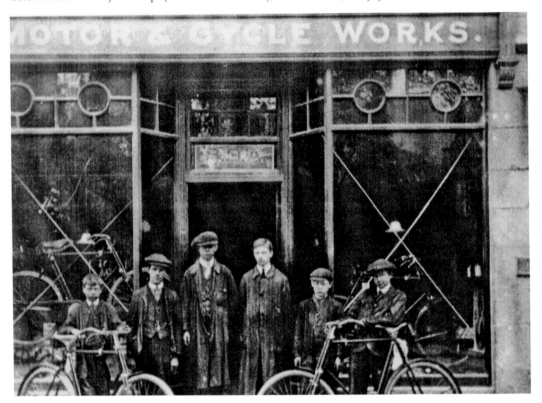

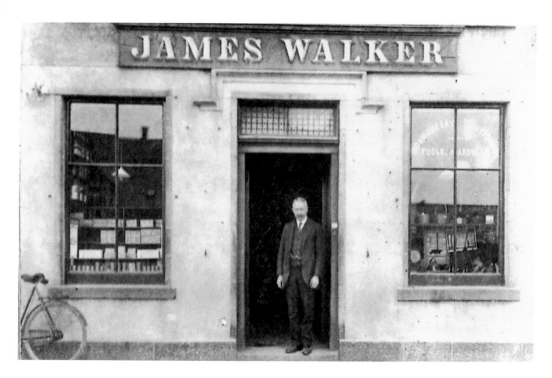

Above: James Walker, chemist, no. 21 the Square.

Below left: James Walker, chemist, in his shop at no. 21 the Square, January 1936.

Below right: Neil Ross filling station and garage in the Square, 1935. Note the penny-farthing bicycle above the Neil Ross sign.

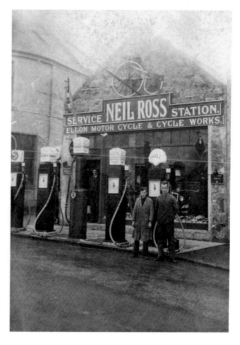

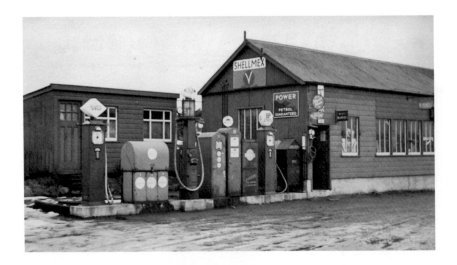

Above: The Craighall garage, 1930s.

Below: Craighall garage: From left to right: Ivor Birnie, Eddie Matthews (snr) and Jimmy Matthews, 1940s.

 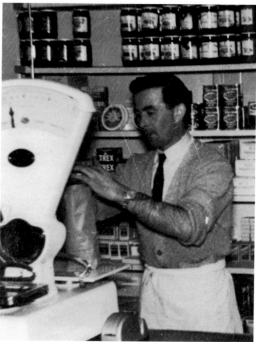

Above left: Chas Watson and James Mutch outside the grocer's shop at no. 20 the Square, 1945.

Above right: William Watson, poulterer and grocer, no. 20 the Square, 1950.

Below: Bill Forbes outside the Buffet in Station Brae, 1931. This venue was well known for special occasions such as weddings. It also provided a full restaurant facility on a daily basis for those attending the mart, and for school pupils.

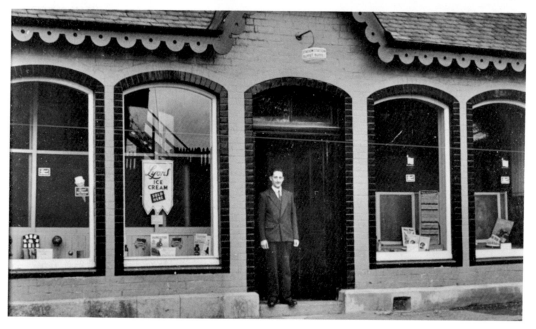

Above: Ythan Terrace, 1973. Note the flourishing market garden.

Below: Alexander's shop in Bridge Street, 1980.

CHAPTER 5

Transport

For some centuries the main forms of transport were by water and by cart. The ford at Ellon provided a vital route across the Ythan for northbound and southbound traffic. A bridge was built in the late eighteenth century, which rendered the ford redundant. A new bridge was opened in 1941 to carry modern traffic, although that traffic has bypassed the town since the 1990s.

The port at Newburgh on the Ythan estuary imported and exported goods, which were transported by river to and from Ellon. This practice ceased in the 1960s.

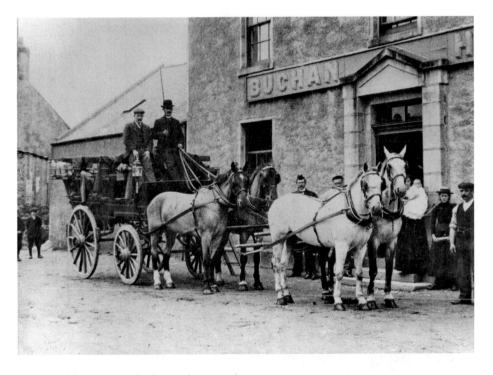

Coach and horses outside the Buchan Hotel, 1900s.

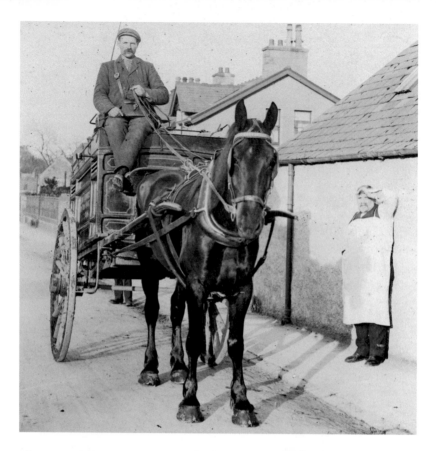

Above: James Moir outside Bruce the baker's, (now Ythan Bakery), pre-1900.

Below: James Moir beside the bakery van, 1920s.

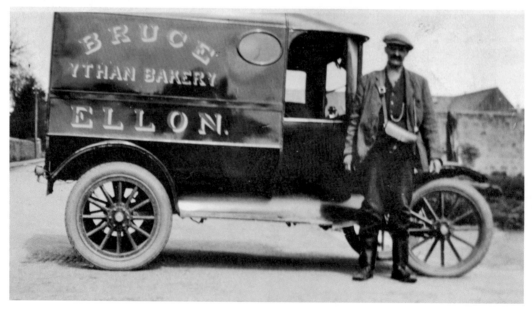

Above: Boat of Fechil ferry, 1912.

Below: Ferry at Logie Buchan, 1920s. Holding the oar is Jean Geddes, with husband James on the right. They were operators of the ferry until the Logie Buchan Bridge was built in 1936. On the extreme left is their daughter Jemima Mortimer.

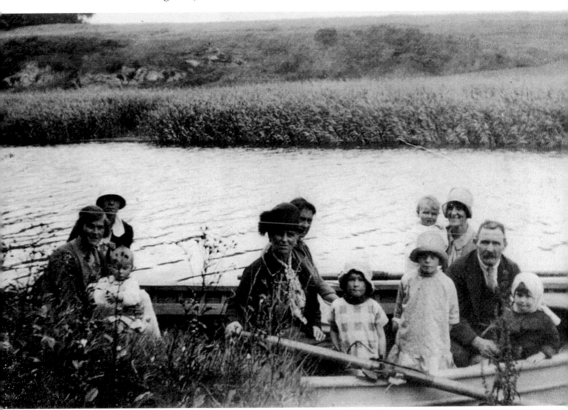

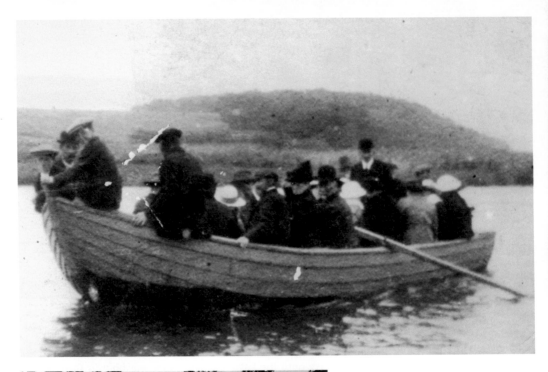

Above: Logie Buchan ferry on the church run, 1900s.

Left: Waterton ferry, 1900s.

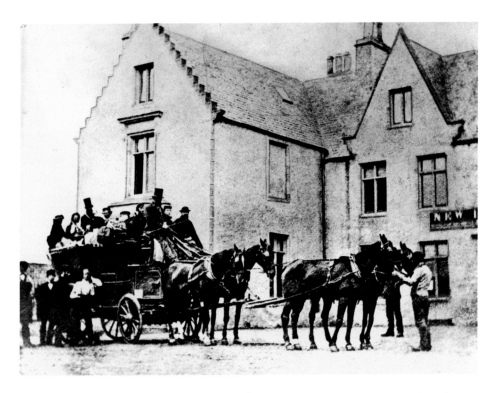

Above: Coach outside the New Inn, 1900s. The New Inn was a staging post where horses were exchanged for fresh ones on the route between Aberdeen and Peterhead.

Below: Coaches outside the New Inn, 1911.

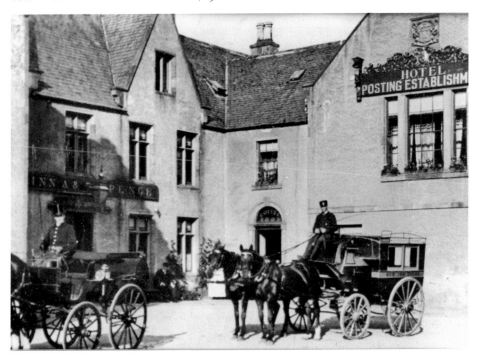

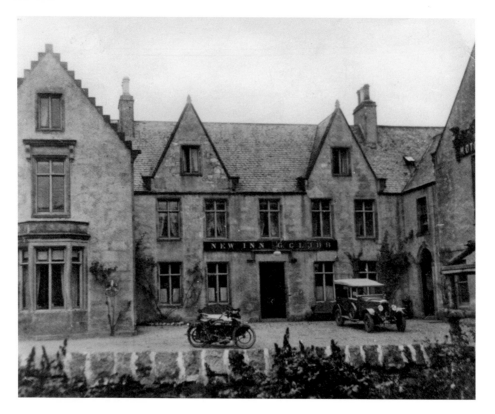

Above: New Inn Hotel, 1921.

Below: An omnibus outside the New Inn Hotel, 1931.

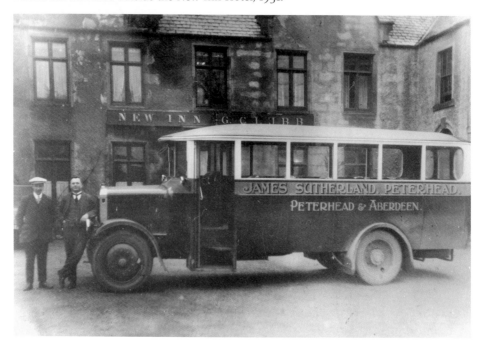

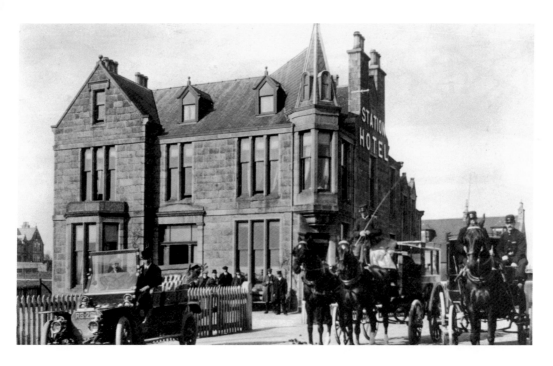

Above: Car and horse-drawn carriages outside the Station Hotel, 1920s.

Below: Railway station with Station Hotel in background, 1900s.

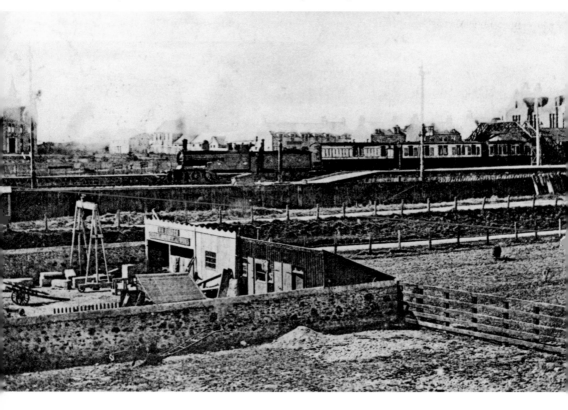

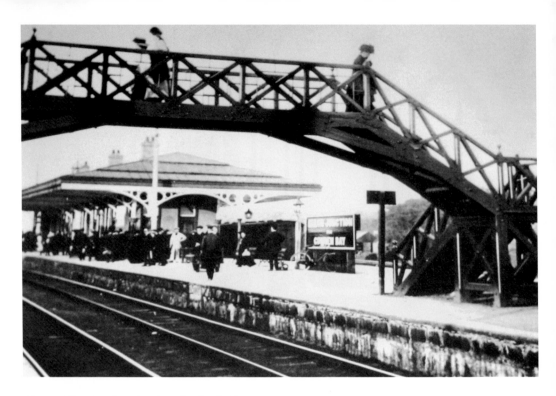

Above: Ellon Station showing the footbridge, 1920s.

Below: Buchan passenger train approaching Arnage Station having left Ellon, 1950s.

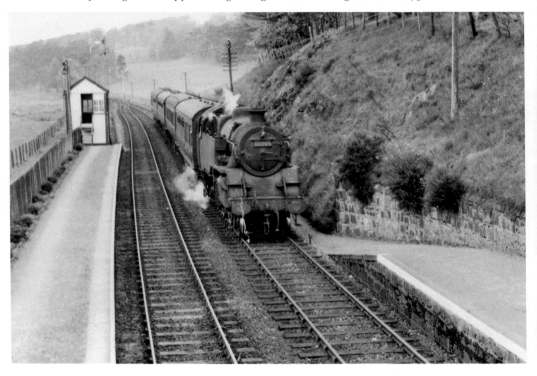

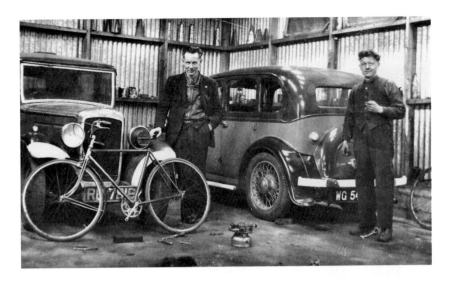

Above: Sammy Davidson and Jimmy Matthews in the Craighall garage, 1930s.

Below: Helen Shinnie and Gladys Willox outside the John B. Willox garage, June 1960.

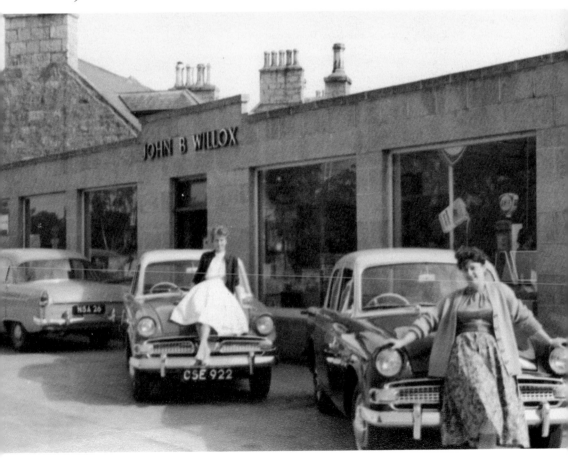

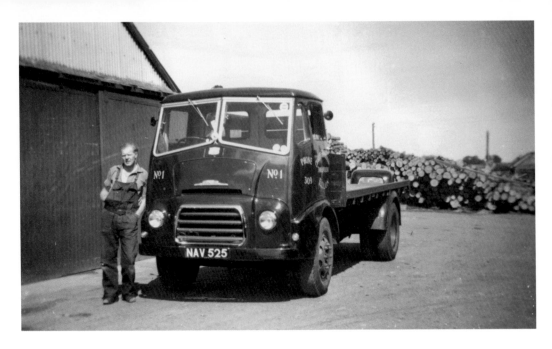

Above: Bill Davidson with flat-bed truck, 1950s.

Below: Alexander's bus on the New Deer Road, 1972.

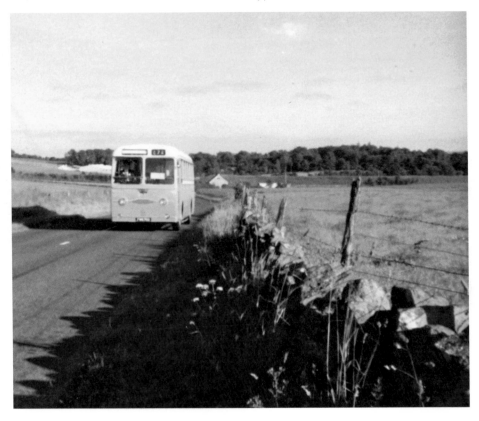

Chapter 6

Events

Over the years many occasions of both national and local significance have been celebrated in the town. We are fortunate to have captured some of both types in this chapter.

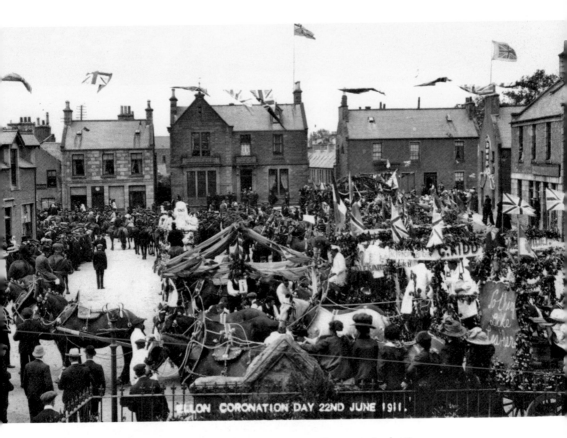

The parade for the Coronation Day of George V on 22 June 1911 in the Square.

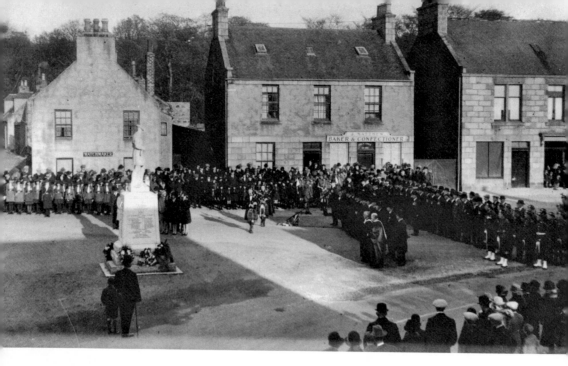

Above: Armistice Day Parade in the Square, 1920s.

Below: The proclamation of King Edward VIII by Ellon Town Council, 1936.

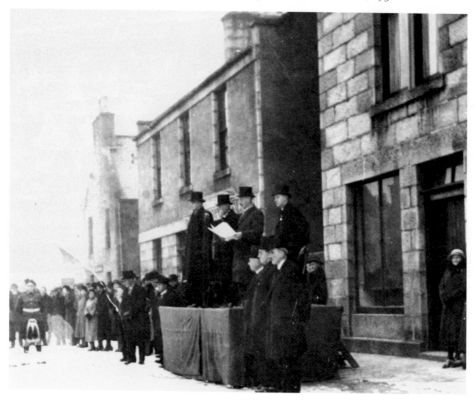

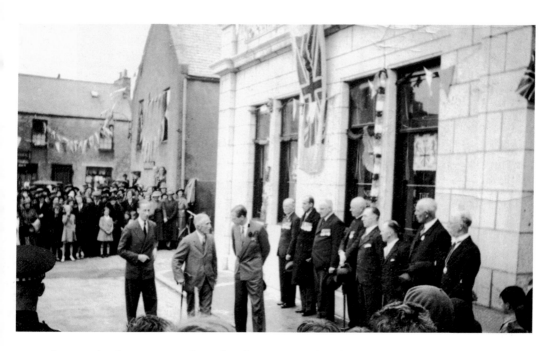

Above and *Below*: In 1939, the Duke of Kent stopped on his way to Fraserburgh where he was launching the new lifeboat.. In these images Sir James McDonald is seen greeting the Duke of Kent. Also present were the Hon. Lady Susan Reid (widow of Sir James), Lady Reid, Master Sandy Reid and Miss Susan Reid, of Ellon Castle, Senior Baillie W. L. Birnie and Baillie Clark.

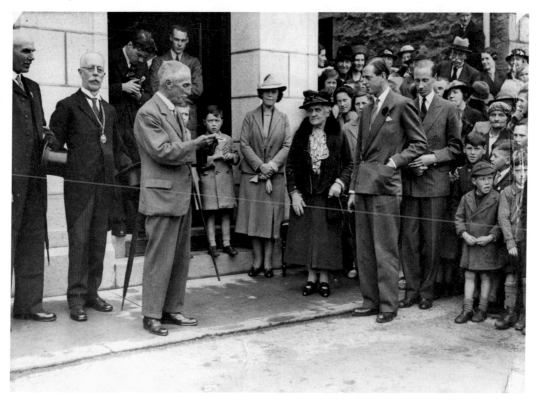

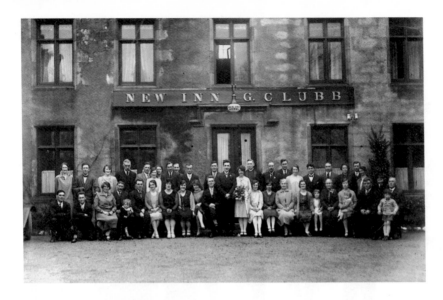

Above: Wedding guests of John and Jess Low, pictured outside the New Inn Hotel in 1940.

Left: A wedding party outside the buffet on Station Brae in 1921.

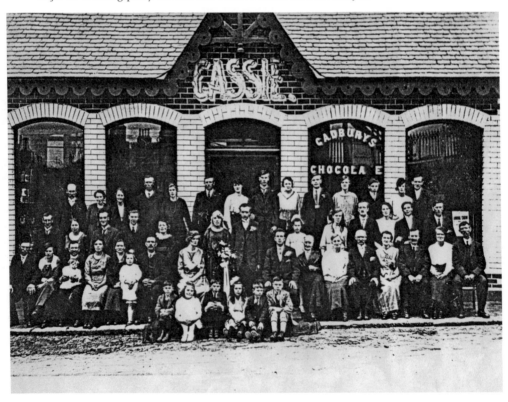

Above: Preparing to build the new bridge across the River Ythan, 1939.

Below: Opening of Gordon Park swings, 1940s.

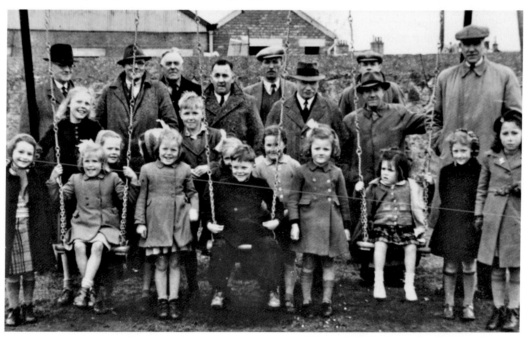

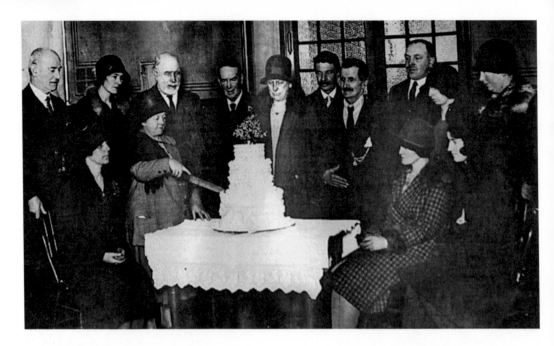

Above: Party held in the Victoria Hall in 1930 by the Hon. Susan Reid for the children of the burgh and their parents. The party was to celebrate the marriage of her son Sir Edward Reid to Tatiana Fenoult. From left to right: Donald Cameron (headmaster), Miss Tocher (teacher), Miss Mackie (teacher), Mrs Cameron (headmaster's wife), Robert Burgess (builder), Mr W. Alexander (savings bank manager), Miss French (infant teacher), Mr Gibson (castle gardener), Mr McRae (slater), Mr George C Burgess (carpenter and undertaker), Miss Sievewright (primary teacher), Miss Kennedy (primary teacher), Miss Donald (teacher), and Miss Will (Latin teacher).

Below: Ancient Order of Foresters 50th anniversary. From left to right: Jimmy Lendrum, John Leslie, Louis Thomson, Davie McGill, Mr Hardie, -?- , -?- , -?- , Willie McKay, Mr Mair, Jimmy Robb.

Above: Ellon Townswomens' Guild donating a public bench on South Road in 1978. The party includes Jean Grieve, Jessie Kirton, Bob Duncan, Betty Duguid, Peggy Burnett, Annie Watson and Lil Ingram.

Below: The annual summer buffet outing for staff, temporary staff and friends in 1953. The driver on the extreme right is Jimmy Sommerville, who for many years, and in all weathers, provided a bus service from Ellon to Aberdeen. Next to Jimmy is Bill Forbes who owned the buffet.

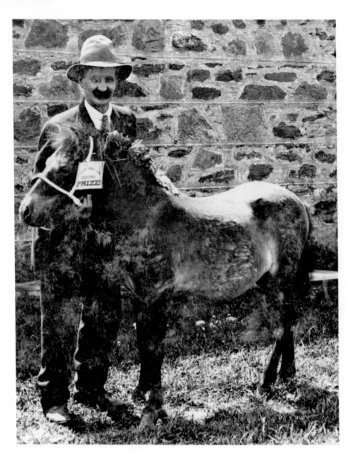

Left: Farquhar McRae with a winning foal at the Ellon Show, 1910.

Below: Kenny and Kathleen Robertson get a ride on a pony and trap at Ellon Show in the 1960s.

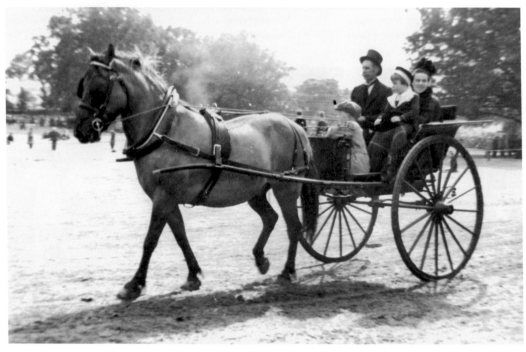

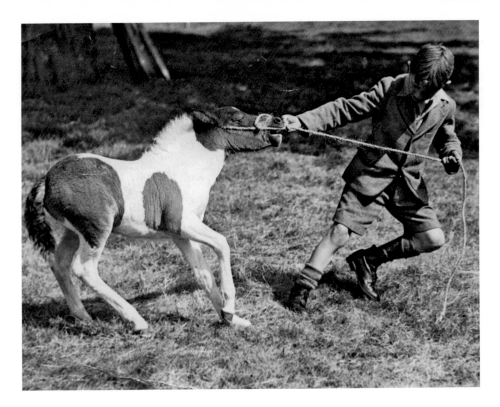

Above: Vernon Cantlay having a struggle with his pony at the Ellon Show in 1947.

Below: Ellon Show Committee members: Sandy Low, John Smith and James Mutch, in the 1970s.

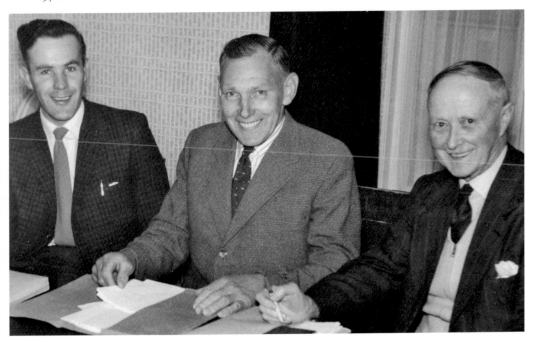

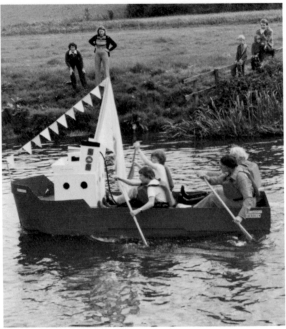

Above left: Bill Smith, former principal teacher of Art at Ellon Academy, who organised the Ellon Raft Race for twenty-two years.

Above right: *Star Canopus* on the first Raft Race day, 1979. The crew is Vernon Cantlay, Brian Ramsay, Sally Cantlay and Gavin Cantlay. The raft was built by Vernon.

Below: Ellon Raft Race, June 1982. From left to right: -?- , Gregor Smith, John A. Cameron, -?-.

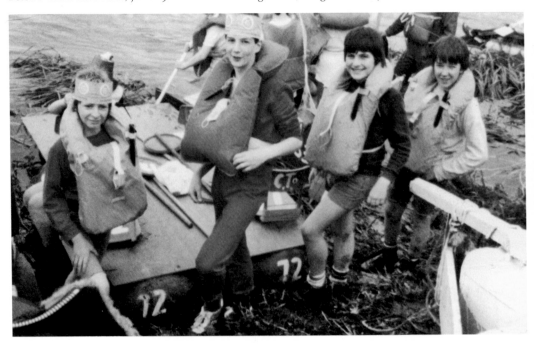

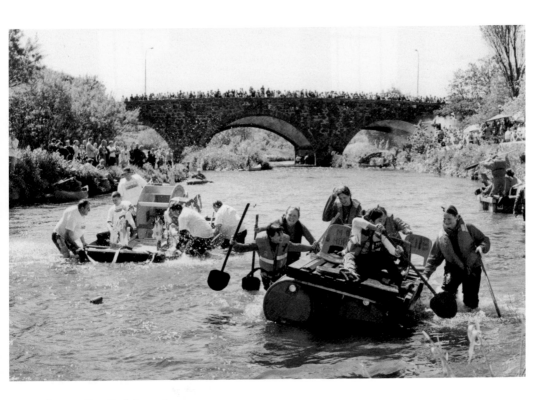

Above: Ellon Raft Race, June 2000.

Below: Third Raft Race, June 1981. *Nessie* was crewed by Gavin Cantlay, James Morrison, Bruce Webster and Vernon Cantlay, who built it.

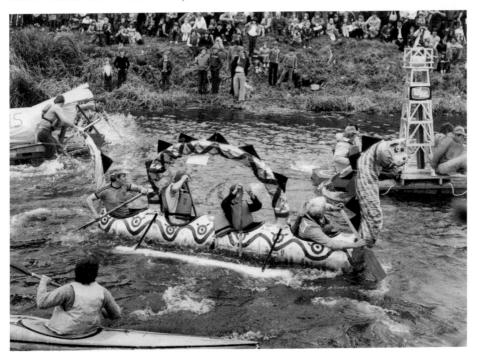

Above: Wattie Gill and Stan Watson at the Ellon Flower Show, 2002.

Below: Louise and Ashleigh Grant, and Elaine and Karien Robbie, prizewinners at Ellon Flower Show, 2002.

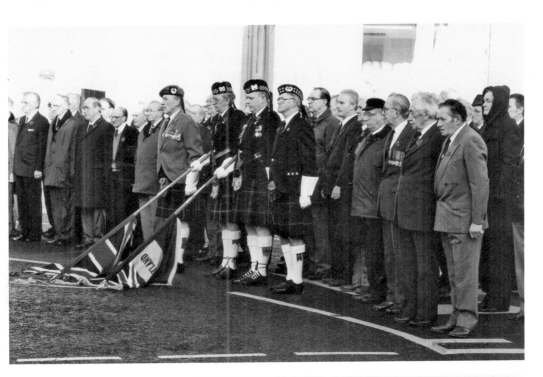

Above: Royal British Legion paying their respects at the Armistice Day Parade in the 1980s.

Right: Ellon Academy pupils building a sandcastle in 1988. This went into the *Guinness Book of Records* as the longest sandcastle ever made.

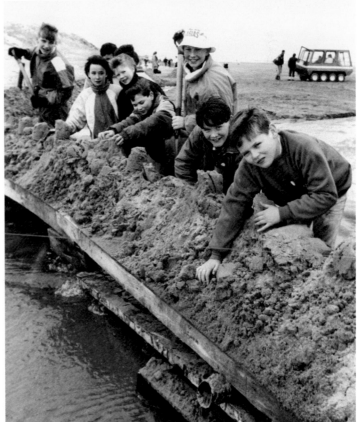

CHAPTER 7

Social Matters & Activities

In order to bring structure to the life of the town, fill leisure hours and expand the cultural aspirations of the townsfolk many groups were formed. The churches and schools played a large part in the development of some of them, while the initiatives of individual members of the population led to the success of others. The town also benefited from the generosity of some who granted funds to provide certain public amenities.

Many of the groups in Ellon raise funds to help local, national and international charities.

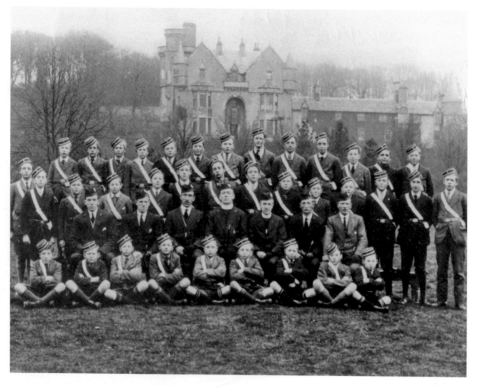

Ellon Boys' Brigade in the 1920s in front of Ellon Castle.

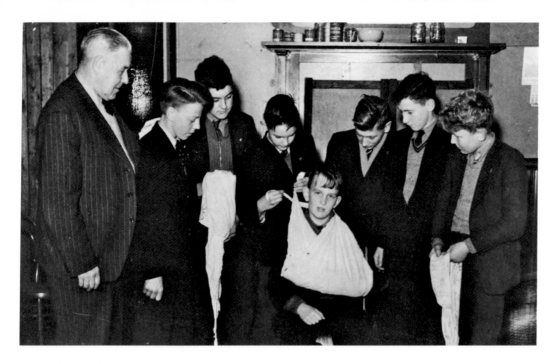

Above: Ellon Boys' Brigade first aid night with instruction from Provost James Davidson. From left to right: A. Paterson, Gordon Fraser, Lock Parker, Jimmy Duncan, George Irvine and Bill Duncan, and Mike Taylor as the patient.

Below: Lifeboys from Ellon Company with Revd Gibson in 1960.

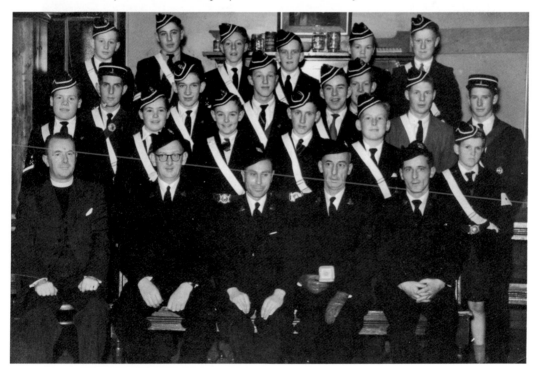

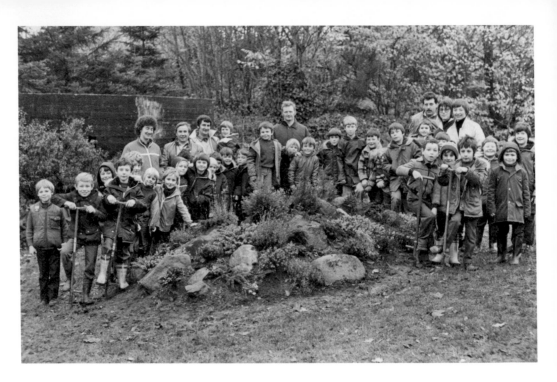

Above: Anchor Boys planting bulbs in McDonald Park (Sievewright Gardens) in 1982.

Below: Ellon Boys' Brigade celebrates eighty years of the Boys' Brigade Movement in 1979.

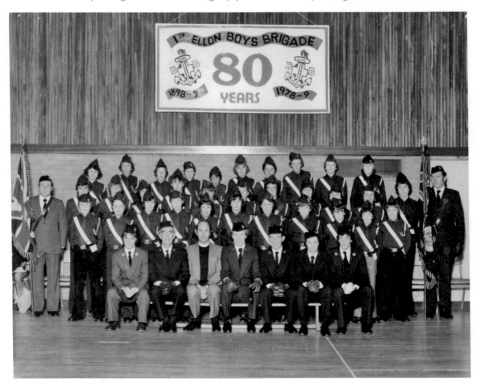

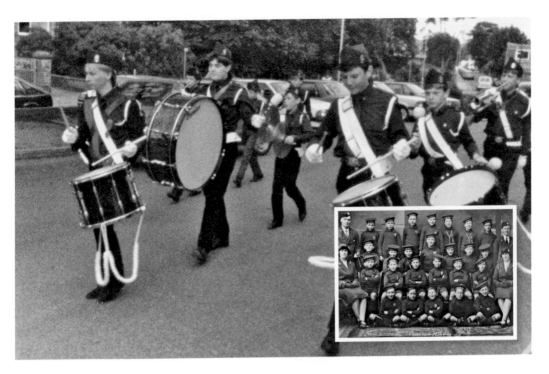

Above: Ellon Boys' Brigade Band. As well as playing regularly in the town, the band took part in national competitions. From left to right: Gary Duncan, John A. Cameron, Andrew Douglas, Alistair Douglas, David McKay, Gordon Forster.

Inset: Ellon Lifeboys, 1930.

Below: Lifeboys, 1950s.

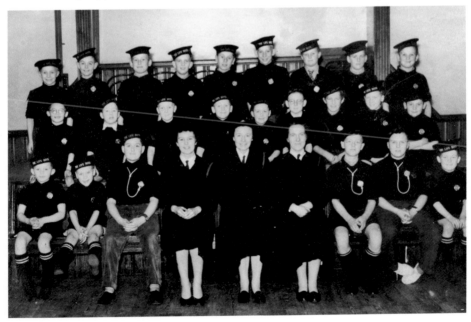

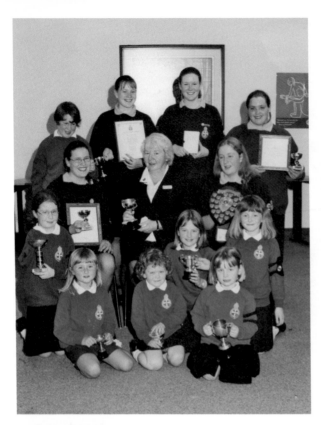

Left: Ellon Girls' Brigade annual presentation, 2002. Receiving their awards from Sheila Buchan, training officer for Girls' Brigade Scotland, are, from left to right, back row: Fiona Jones, Valerie Paton, Claire Adamson, Heather Fraser. Middle row: Jenni Paton, Calaidh Paterson. Front row: Sarah Reid, Ceilidh Alexander, Bebhinn Paterson, Louise Grant, Ashleigh Grant, Aisha Walker.

Below: Ellon Boy Scouts Andrew Morrison, Liam Paterson and Graeme Cox with leader Norman Bruce, 1980s.

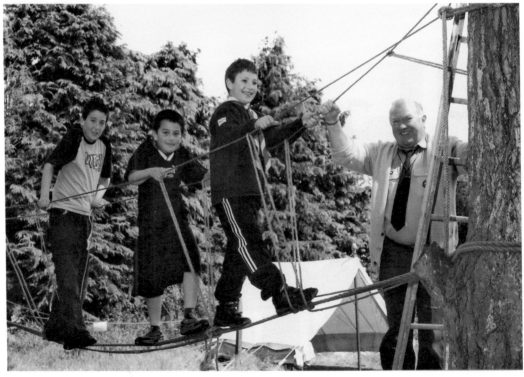

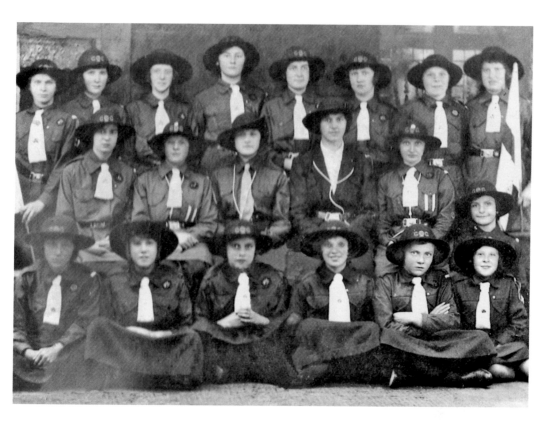

Above: 1st Ellon Guides in 1923/24. The leaders were Miss Green and Miss Hazlewood.

Below: 1st Ellon Guides in 1942/43. The guiders were Miss Davidson and Miss Lippe.

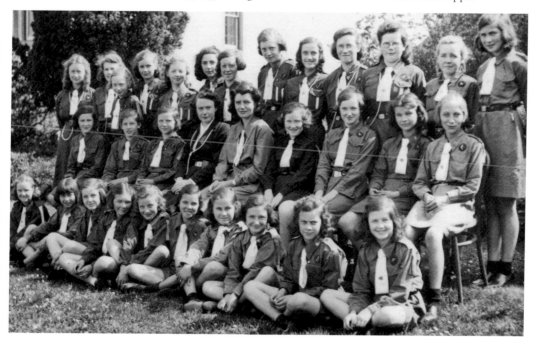

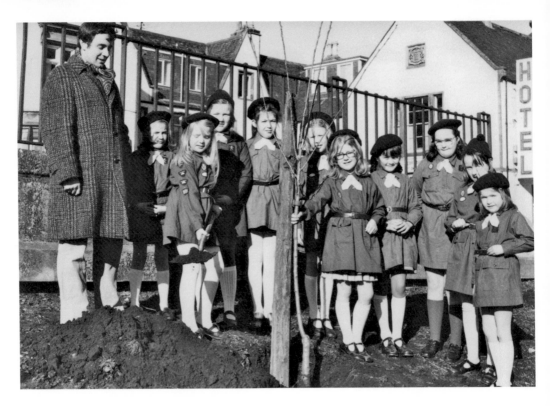

Above: 'Plant a tree in '73'. Ellon Brownies plant a tree in Riverside car park. With them is Councillor Bob Duncan.

Below: Ythan Fiddlers concert in 2000.

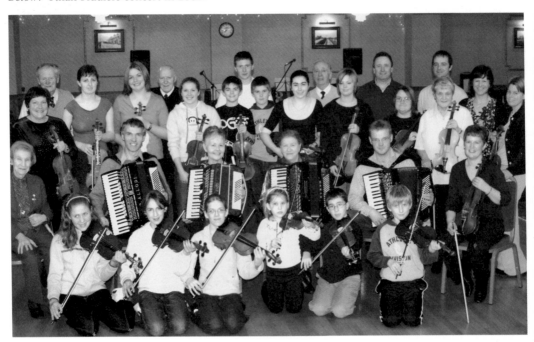

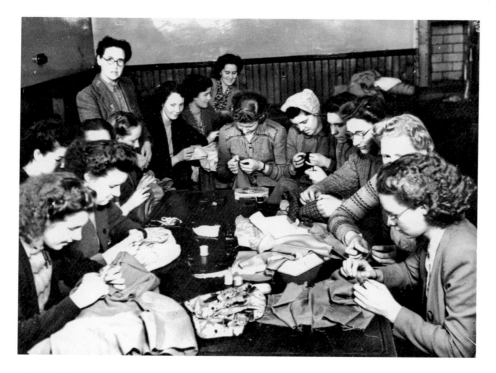

Above: Ellon Youth Club sewing class, 1950s.

Below: Ellon Youth Club woodwork class, 1950s.

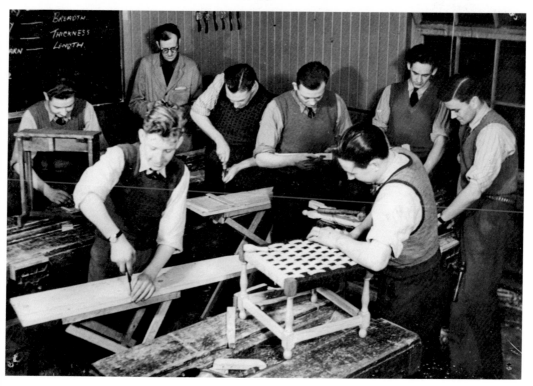

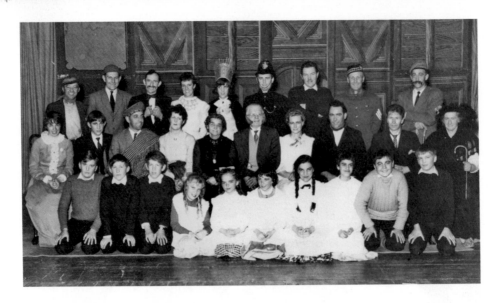

Above: Ellon Drama Club. – Cast of *Mains's Wooin'*.

Below: Ellon Drama Club, 1940. The play was *Storm in the Manse*. The cast included May Forbes, Bertie Bruce, Helen Collie, Maggie Watson, Gunner Duncan, Bessie Hardie, Maimie Duncan, Bobby Hogg, Eck Bruce, Henry Mutch, Betty Riach, Popsie Thomson and Jimmy Matthews.

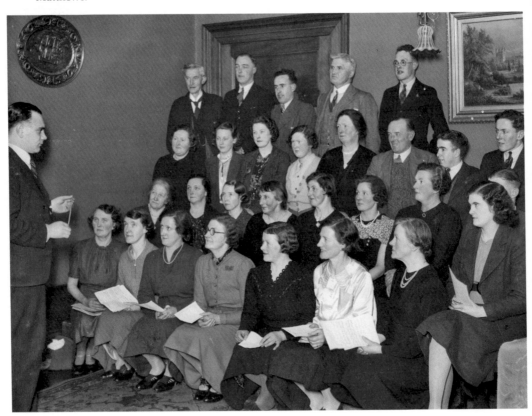

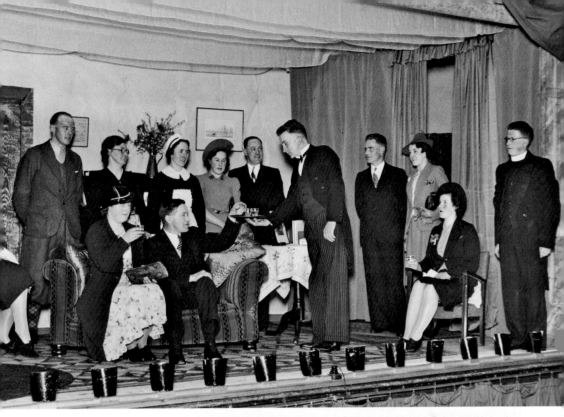

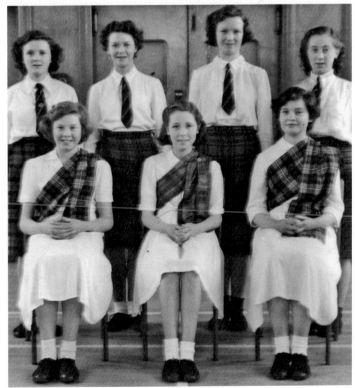

Above: Ellon Drama Club, 1940. The play was *Storm in the Manse*. The cast includes: May Forbes, Bertie Bruce, Helen Collie, Maggie Watson, Gunner Duncan, Bessie Hardie, Maimie Duncan, Bobby Hogg, Eck Bruce, Henry Mutch, Betty Riach, Popsie Thomson and Jimmy Matthews.

Right: Ellon Academy Dancing Team, 1959. From left to right, front row: ? Finnie, Betty May Smith, -?- , Margaret Gibb. Front row: Ellen Mutch (Bartlett), Patty Smith (Argo), Kathleen Buchan.

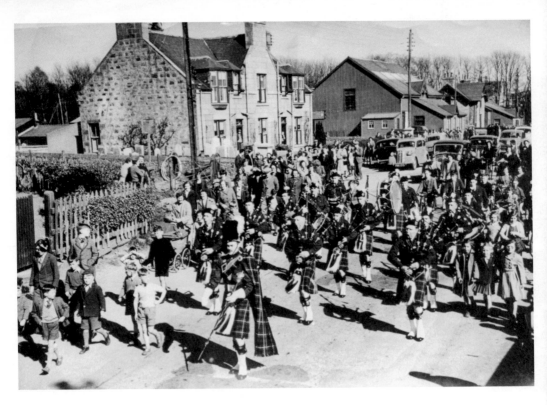

Above: Ellon's first pipe band led by Drum Major Cruickshank with pipers Sammy Robertson, left, and George Thom, right, 1940s.

Below: Ellon Royal British Legion Pipe Band, 1970s. The uniforms were made by converting bus drivers' jackets!

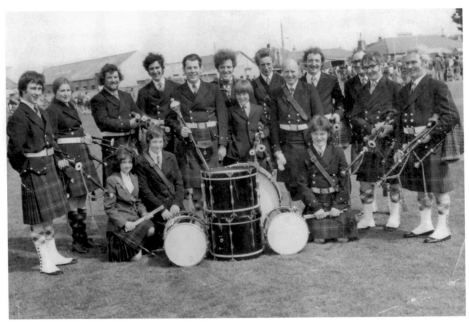

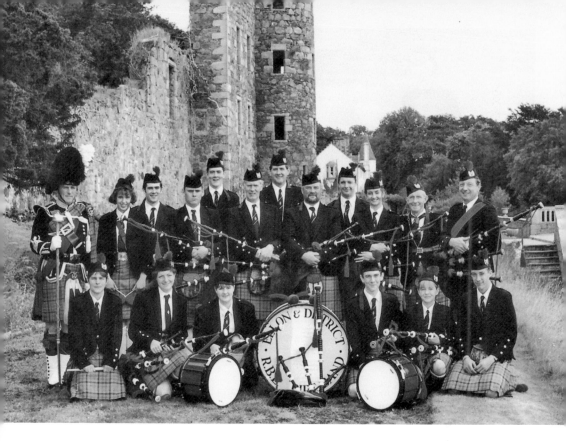

Above: Ellon Royal British Legion Pipe Band in front of the ruins of Ellon Castle, 1996.

Below: The Arcadians dance band, 1940s.

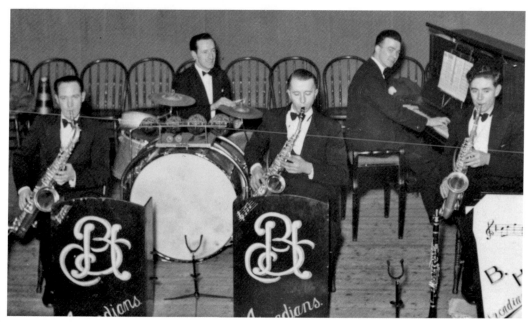

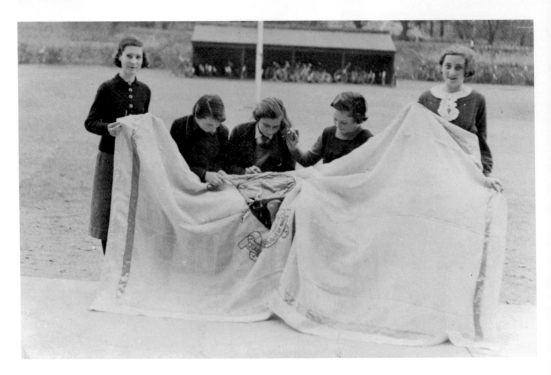

Above: Flag presented to Ellon Burgh by Netta Hardie, Margaret Stephen, Jessie Strachan, Georgina Ironside and Isobel Oliphant in 1937. The three in the centre of the group stitched the flag.

Below: Provost Davidson greets the Burgomeister from Chièvres. In 1967, Chièvres and Ellon signed a twinning agreement.

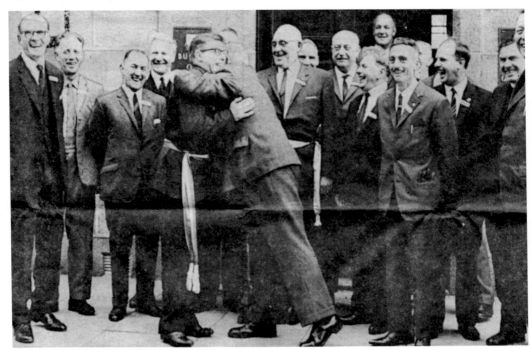

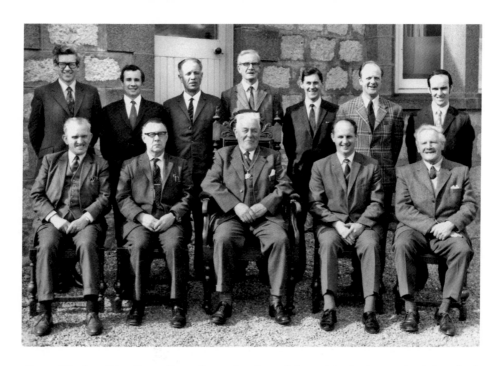

Above: The last Ellon Town Council, 1974/75. From left to right, back row: Fred Crawford, Bob Duncan, Burgh Surveyor James Dinnes, Town Clerk George Raeburn, Burgh Chamberlain R. W. Reid, Jack Reid, Peter Ritchie. Front row: Bill Bruce, John Cordiner, Provost Davidson, Baillie Lindsay Halliday, Treasurer George McGowan.

Below: First Community Council, 1976. From left to right, back row: Tony Bullock, Lindsay Halliday, Bill Bruce, Gordon Paterson, Bob Innes, Cameron McIntosh, Peter Ritchie. Front row: Gerald Stranraer-Mull, Frances Crawford, Sybil Fowler, Bob Chalmers, Phyllis Nicol, Kathleen Allan, Bob Duncan.

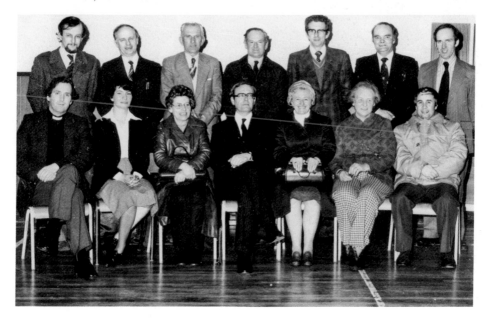

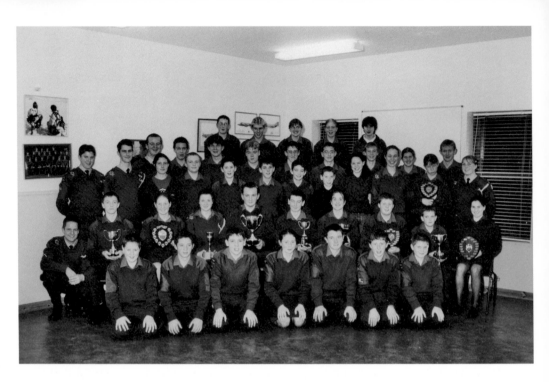

Above: Ellon Air Training Corps 1990 Squadron at their annual presentation in 2000.

Below: Ellon Army Cadets, 2000.

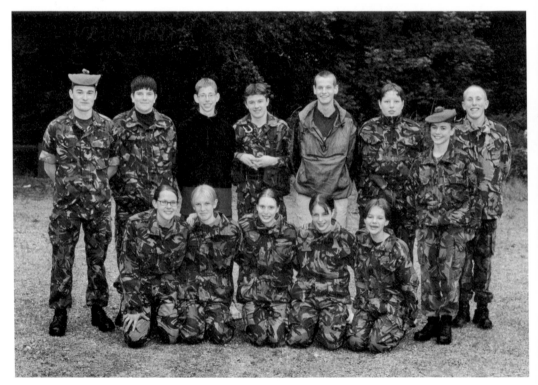

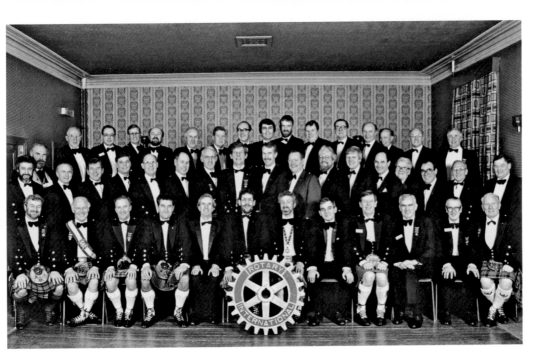

Above: Ellon Rotary Club, 1990. Back row: Doug Westland, Sandy Gray, John Glennie, Graham Bruce, Phil Mills, Leslie Shearer, Gordon Willox, Alasdair Campbell, Ian McKay, Michael Taylor, Albert Tawse, Ian Riddell, Brian Milne, Gerald Moore, Peter Elrick, Bob Duncan. Middle row: Revd Bill Murdoch, Bill Thomson, Ken Gill, Rory Menzies, Ron Davidson, David Presly, Alistair Massie, Bob Forman, Doug Winchester, George Ironside, Forbes Hamilton, Brian Wilkins, Revd Matthew Rodger, Jimmy Duncan, Sandy Davidson, Wallace Davidson. Front row: Alan Cameron, Lindsay Cook, Charles Burgess, Gordon Fraser, Graham Gerrard, Jim Anderson, Alan Donaldson, Alistair Machray, Donald Phillip, Alasdair Fraser, Charlie Esson, Arthur Watson.

Below: Inner Wheel 10th anniversary, February 2003.

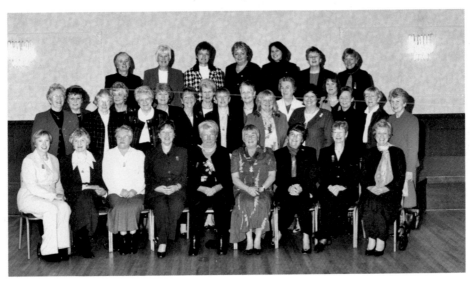

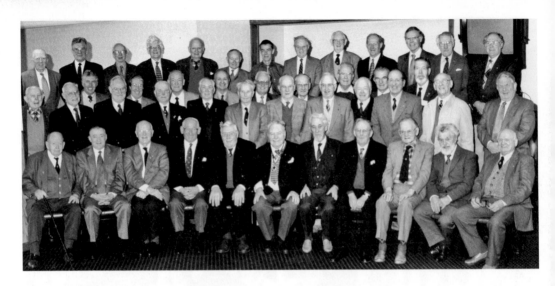

Above: Ellon Probus Club members, 13 January 2000. From left to right, front row: Peter Knowles, Don Raitt, Lewis Mackie, Joe Penny, Arthur Fry (Vice-President), Ian Millar (President), Charles Robertson, Leighton Johnson, Archie Henderson, John Kelsall, Jack Gibb. Second row: Jim Bryson, Frank Duguid, George Gall, George Leiper, Victor Hudson, Robin Simmers, Alex Daun, Frank Middleton, Doug Watson, Sonny Alzapiedi, Alex Young, Ted Bannister. Third row: Ian Roberts, Duncan Milne, Bill Forsyth, Robert Anderson, Tom Lothian (1), Bert Wyness, Ron Baston, George Johnston, Ron Chalmers. Back row: John Guiney, John Iddon (visitor), Derek Yelland, Fred Crawford, Ken Adey, Tom Allan, Tom Lothian (2), Jim Fraser, John McLeod, Gordon Gunn, Gordon Laing, David Cross.

Below: Ellon Luncheon Club Christmas lunch. Sheila Innes and Emma Mathers with senior citizens George Shearer, James Kirton and Alec Paterson.

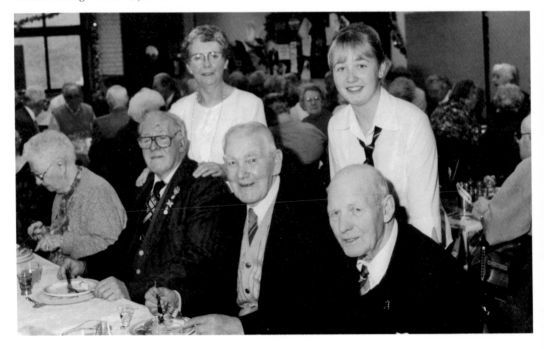

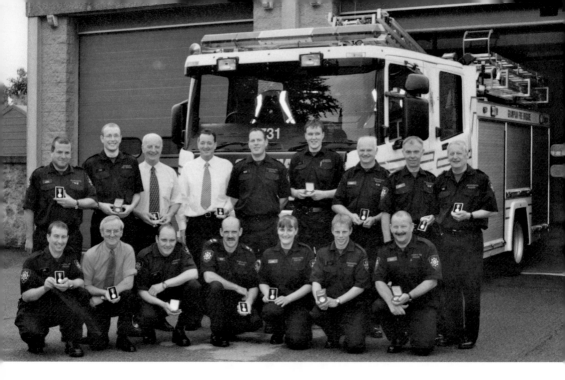

Above: Members of Ellon Fire Brigade showing their Golden Jubilee medals in 2003. From left to right, back row: Derek McKandie, Steven Morrison, Bob Thomson, Gordon Reed, Andrew Hislop, Craig Grassick, Raymond Riddell, Ron Beedie (Station Officer), Kenny Carr. Front row: Robin Smith, Andy Bruce, Jim Stein, Norman Bruce, Lynn Mitchell, Dennis Chalmers, Graham Batty.

Below: Angus Farquharson (Lord Lieutenant) and Charles Burnett (Ross Herald) presenting the new Ellon Coat of Arms to Community Council members Stuart Wale and Moira Muir in October 2000.

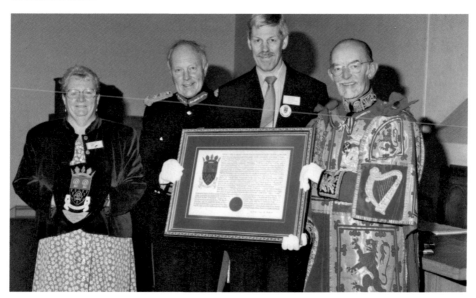

CHAPTER 8

Sports

As the town became affluent, the population had more leisure time. To satisfy this need, many sporting clubs and facilities have appeared within the town. These clubs range from cricket, soccer, rugby, golf, curling and hockey to walking groups and fun events like the famous Ythan Raft Race and the more recent Pedal Car Race. There are many more and the Meadows sports complex provides a variety of activities.

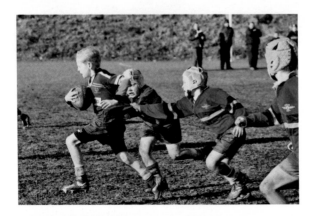

Left: Ellon Meadows P5 mini rugby, March 2002.

Below: The Ellon curling rink on Golf Road in the 1900s.

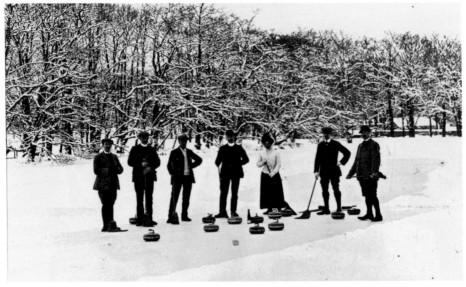

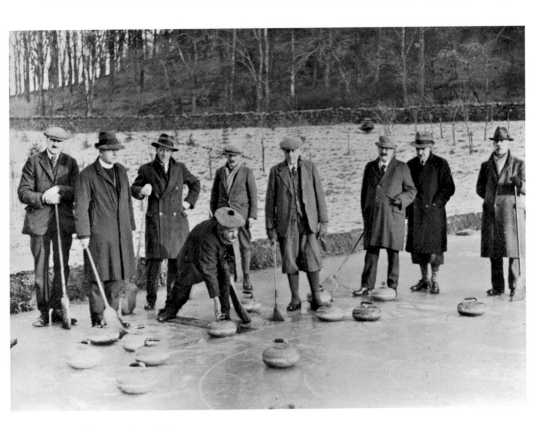

Above: Ellon Curling Club, 1930s.

Below: Ellon Quoiting Club, winners of the Murray Cup, 1908. A young Farquhar McRae is in the middle of the back row.

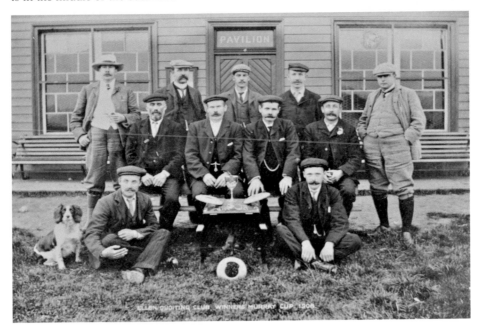

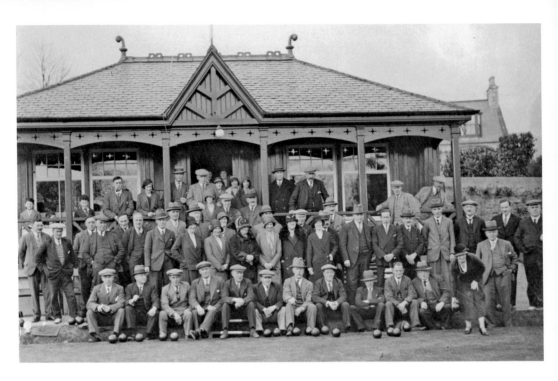

Above: Opening of the Bowling Club season, 1930s.

Below: A crucial measurement! Ellon Bowling Club, 1930s.

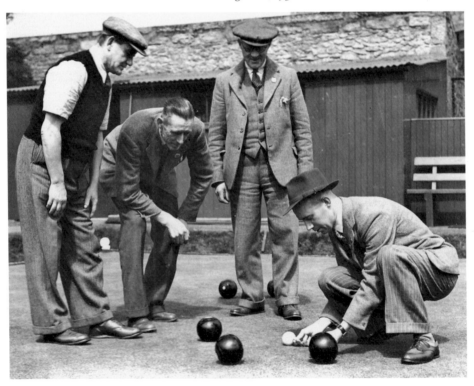

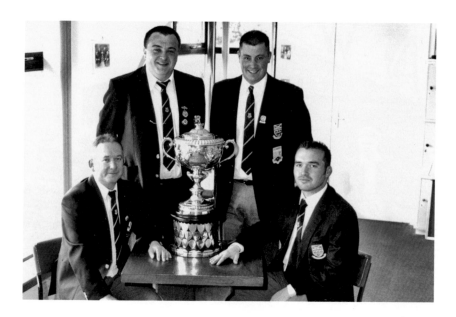

Above: Members of Ellon Bowling Club showing off the Skillymarno Cup, which they won in 2000. Back: Mike Stephen, David Stevenson. Front: Gary Simpson, Lee Thomson.

Below: Ellon Rifle Club. Sandy Davidson (centre front) with his winning cup in 1952/53.

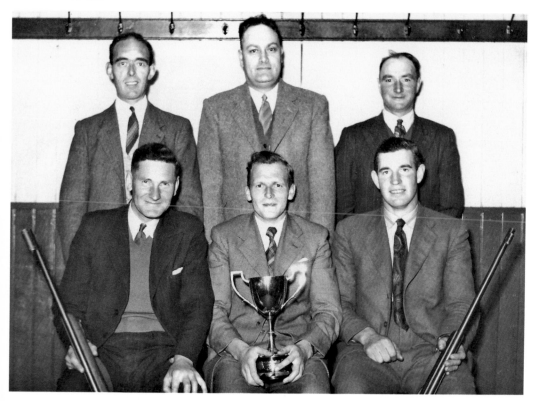

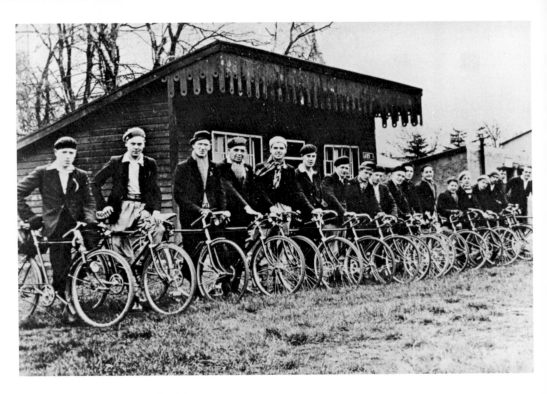

Above: Ellon Wheelers Cycle Club, 1936.

Below: Ythan Cycle Club, April 2001. From left to right: Andy Turner, Sally Ashbridge, Charlie Allan, Steven Argo, Alan Yateman, Lorna Adam, Bill Dallas.

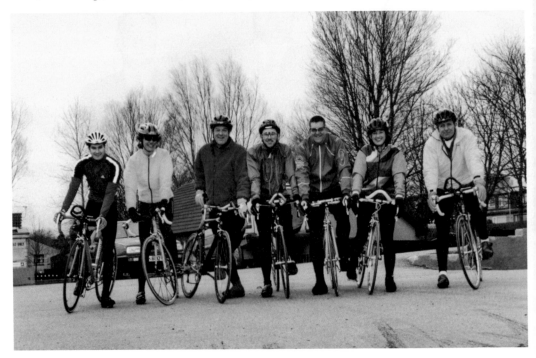

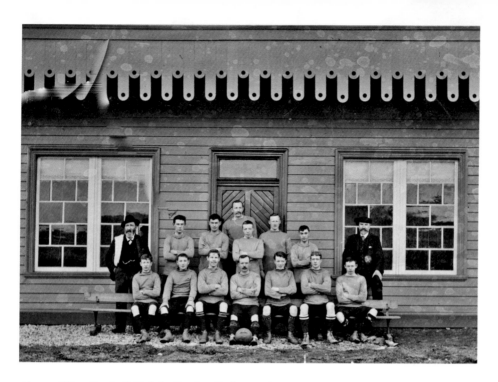

Above: Ellon Football Club in Gordon Park, 1903/04.

Below: Allan Moir (goalkeeper) and Doug Scott (centre half) playing for Ellon Thistle in the 1930s.

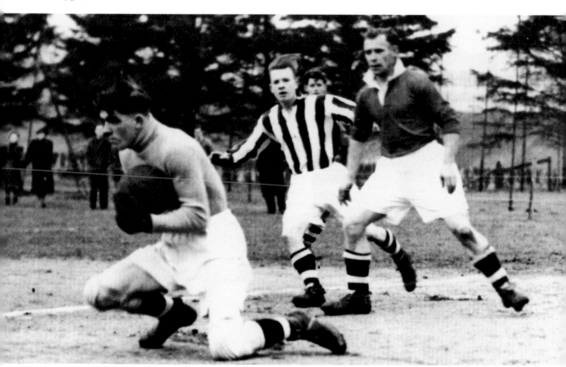

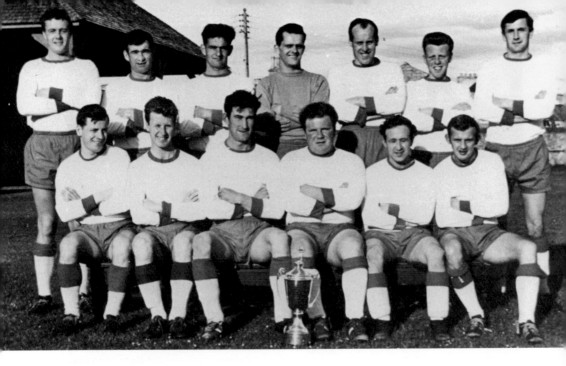

Above: Ellon United with the North of Scotland Cup, 1964/65 season. From left to right, back row: Bowie, W. Wood, Cowieson, Ahern, Robson, Paterson, Duncan. Front row: Hay, Simpson, M. Wood, Wallace, Morgan, Elrick.

Below: Ellon United Football Team, 1967. From left to right, back row: Freddie Ireland, Lindsay Halliday, Bert Gray, Gerald Cowie, Dougie Bonner, Eric Thomson. Front row: Ronnie Brinklow, Bill Finnie, Eddie Lawrence, Tootie Cowe, Gordon Thomson.

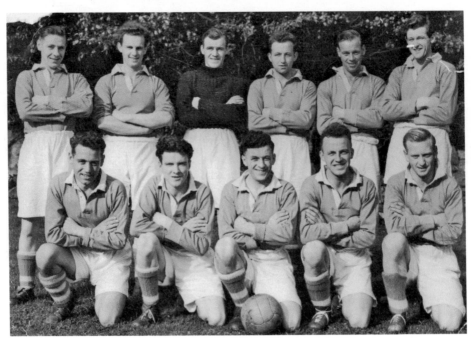

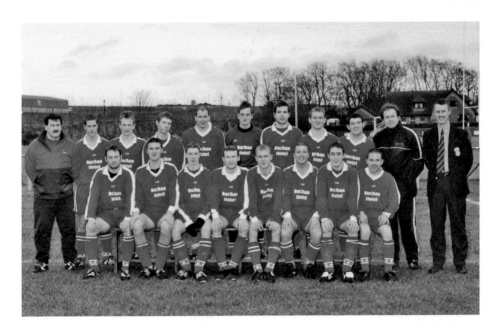

Above: Ellon United Football Team, 2000. from left to right, back row: Bob Scott, David Leslie, Kris Dear, Ryan Ingram, Ally McGinlay, Steve Smith, Lee Roberts, Steve Murray, Graham Hyland, Martin Greig, Ronnie Wells. Front row: Steve Liddel, Owen Collie, Rhian Duff, Greg Paterson, Tommy Willox, Greg Abercrombie, Chris Burr, Bruce Finnie.

Below: The late Teddy Scott – Aberdeen Football Club player, youth coach and kit man for nearly half a century – presenting awards to Ellon United footballers Rhian Duff, Ronnie Wells, Greig Paterson and Tommy Willox.

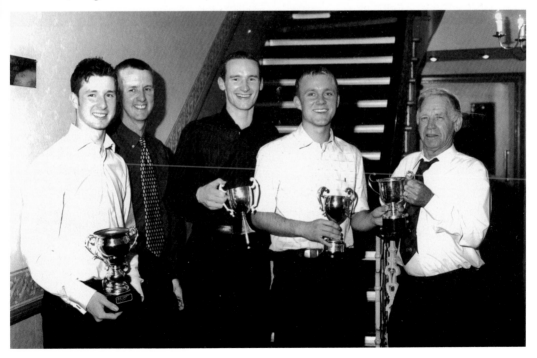

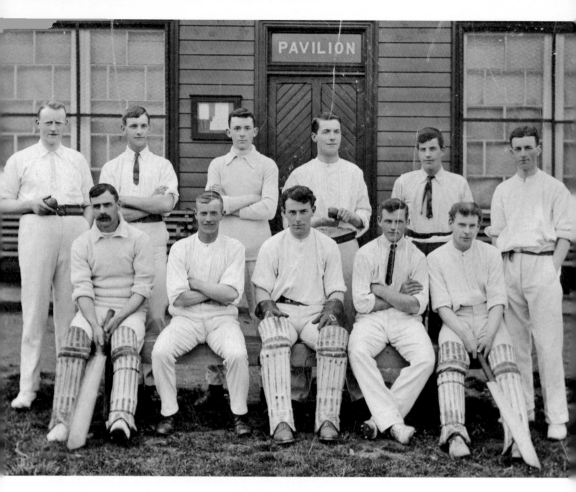

Ellon Gordon Cricket Team, 1920s. John McRae is second from the left in the front row.

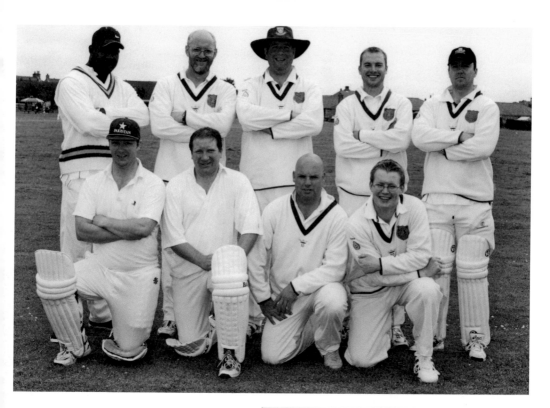

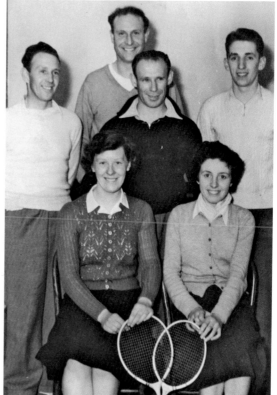

Above: Ellon Gordon Cricket Club, 2003. From left to right, back row: Frank Francis, Andy Park, Scott Middleton, Steve Reid, Steve Anderson, Front row: Andy Churchill, Jon Barrett, Stephen Doak, Chris Watson.

Right: Badminton Club, 1953. From left to right, back row: Jimmy Cassie, Robbie Burgess, Bill Bruce. Centre: Dougie Scott. Front row: Annie Watson, Margaret Wyness.

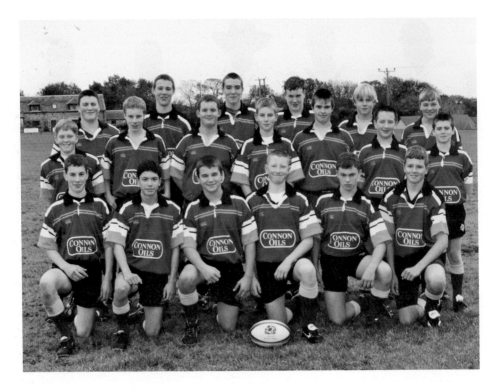

Above: Ellon U15 rugby team, January 2000.

Below: Ellon Rugby Club U18 team, 1995. Michael Ellington has the ball.

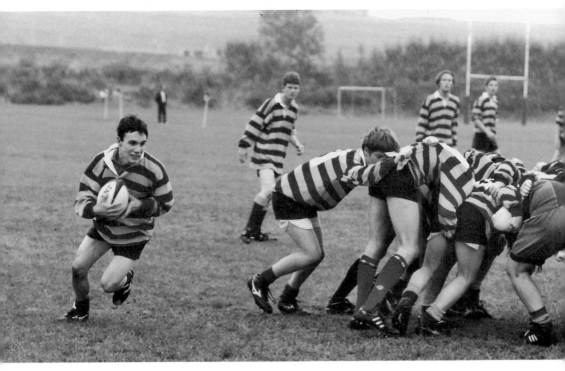

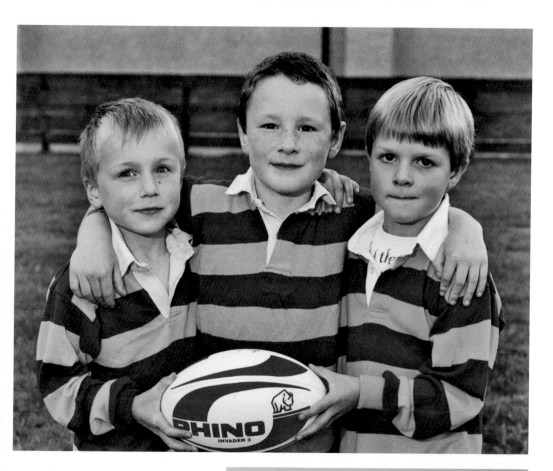

Above: Ellon Meadows Mini Rugby. Pictured are Hayden Millar, David Millar and Jamie Cochrane.

Right: Taekwondo black belts, June 2000. from left to right: Andrew Fergus, Stephanie Sunley, Gaynor Sunley, Laura Fergus and Mark Coughlan.

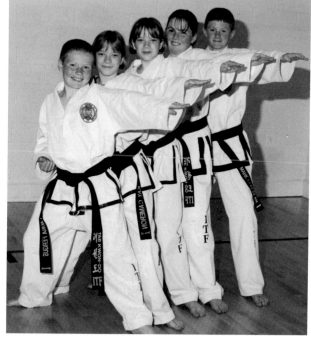

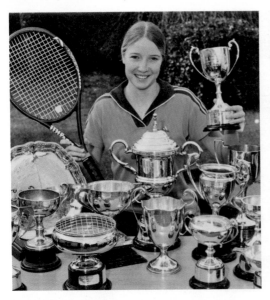
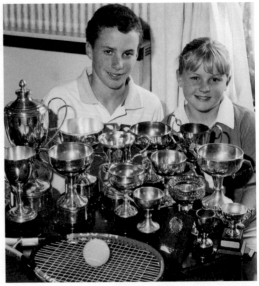

Above left: Jenna Cockburn with her many tennis trophies in February, 2002. Jenna was a junior county player and also played in Scotland's Four Nations tournament.

Above right: Ewan and Claire Birnie who collected many tennis trophies as juniors, 2000. Claire went on to compete at international level and Ewan went on to coach tennis and study Sports Science.

Below: Ellon Meadows Squash Club, March 2002.

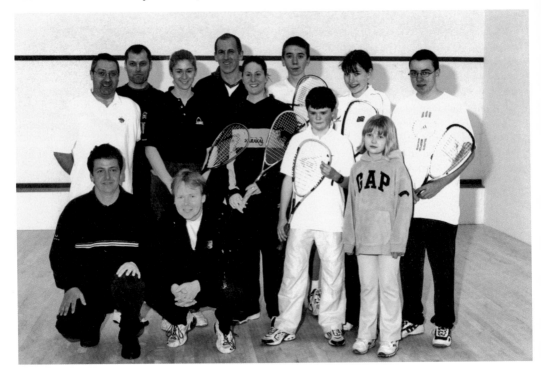

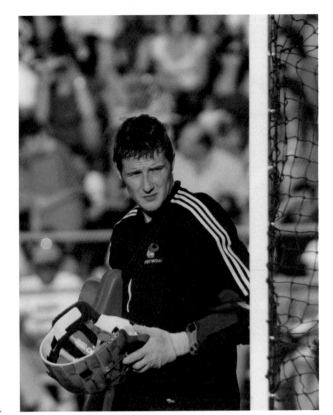

Right: Ali McGregor, who represented Great Britain at Hockey in the Beijing Olympics in 2008. He has recently been installed in the Edinburgh University Sports Hall of Fame.

Below: Ellon Meadows Hockey U15 and U18 teams, March, 2000.

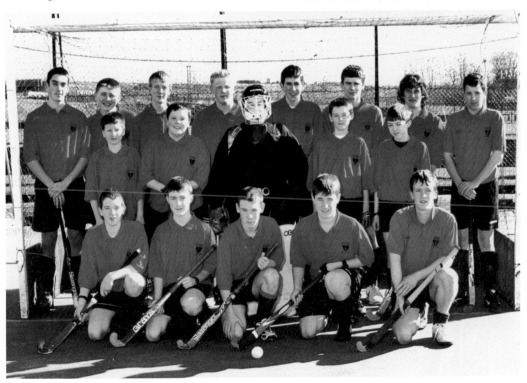

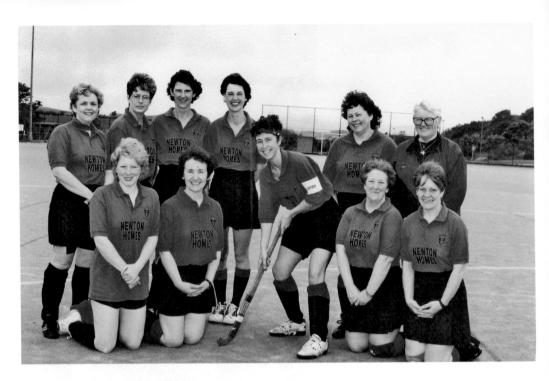

Above: Ellon Ladies' Hockey Club. From left to right, back row: Helen Hill, Alison Becci, Debbie McLachlan, Lorna Adam, Sheila Noble, Aileen Petrie. Front row: Brenda Noble, Janet Anderson, Karen Whitelaw, Brenda Gibb, Marion Morgan.

Below: Ythan Amateur Swimming Club with trophies in 2002.

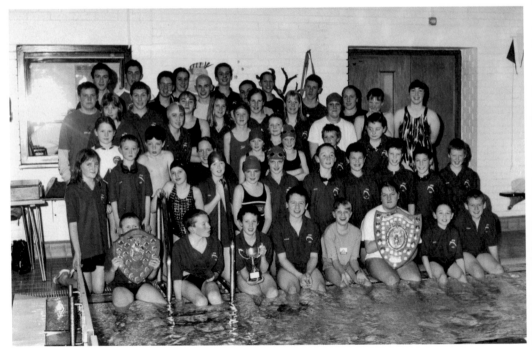

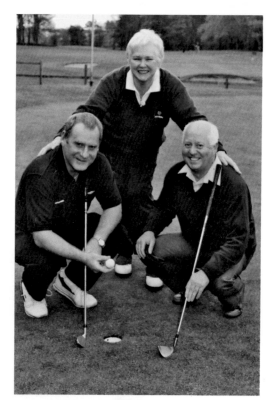

Right: Three holes in one in three days in 2003. Ian Mundie, Alma Wildgoose, John Cartney.

Below: McDonald Golf Club Junior Pennant Team in May 2001.

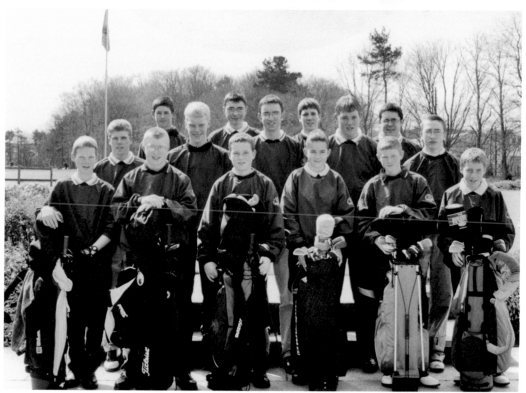

CHAPTER 9

Round & About Ellon

As in any town, the streets, buildings and places within the town have changed over the years. In this chapter we include some views, both old and more recent, that we hope you will find of interest.

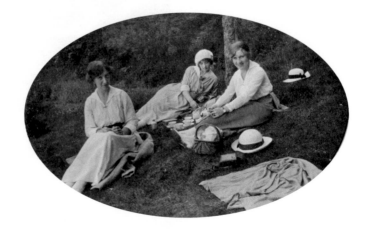

Above: A picnic at Braes of Waterton in 1915.

Below: View from Ellon Castle Terrace in the 1900s.

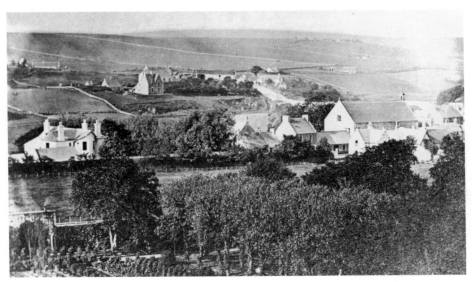

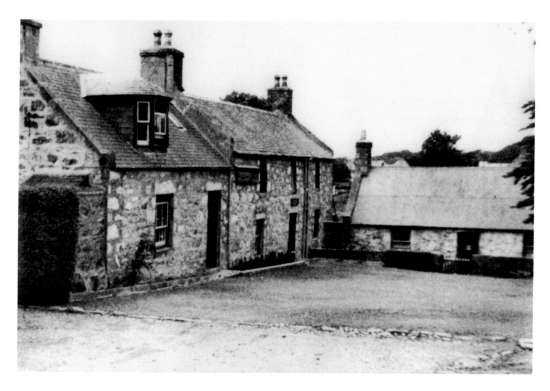

Above: Craighall Inn at the turn of the twentieth century.

Below: Ythan Terrace in 1907.

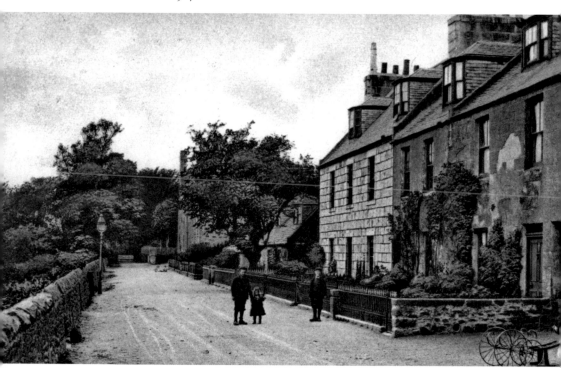

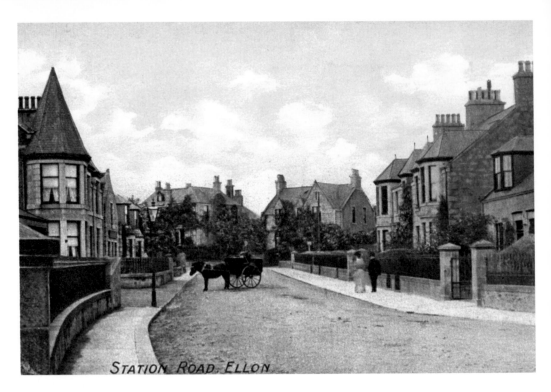

Above: Station Road, 1900s.

Below: Victoria Hall in the 1920s.

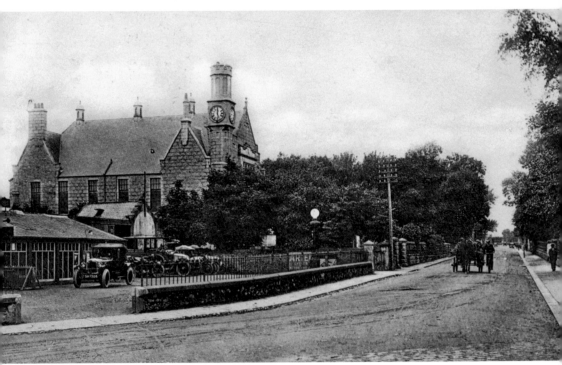

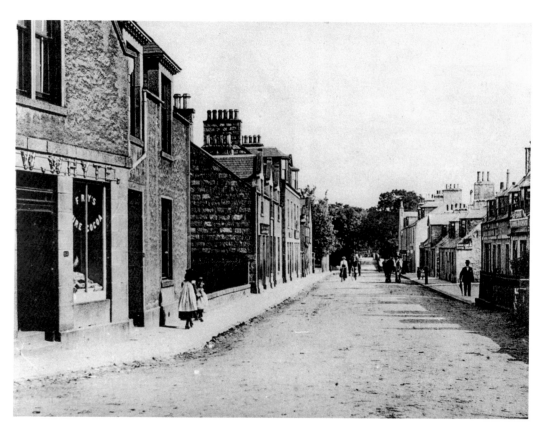

Above: Bridge Street, 1900s. The shop on the left is currently the Ythan Bakery.

Below: 98 Station Road looking west from the railway bridge, showing loading ramps.

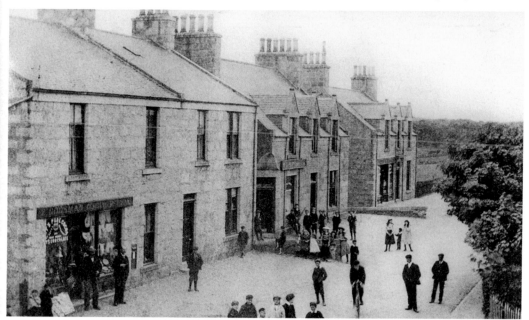

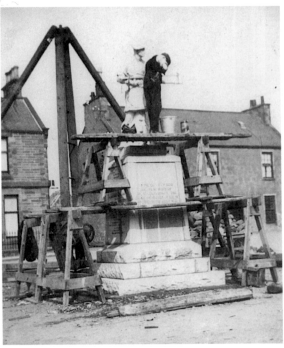

Above left: Douglas Walker, son of James Walker (chemist), at no. 21 the Square in 1923.

Above right: Erection of the War Memorial in the 1920s in the Square.

Below: The first houses built in Gordon Place. The children include Dorothy Duguid (with hat) and Frank Duguid (third from left).

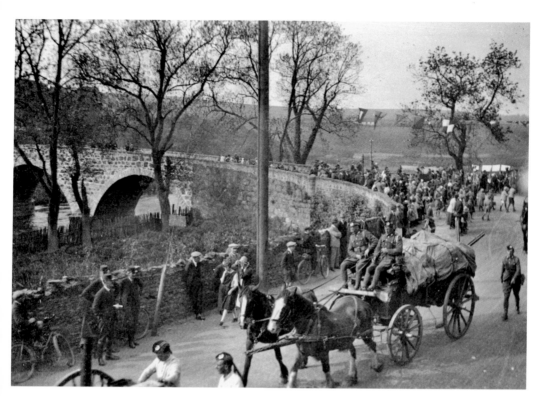

Above: Territorial Force marching through Ellon, before the First World War.

Below: Ythan Terrace market gardens, 1930.

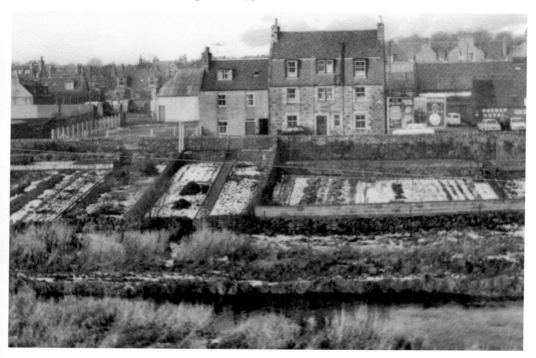

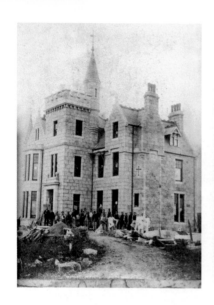

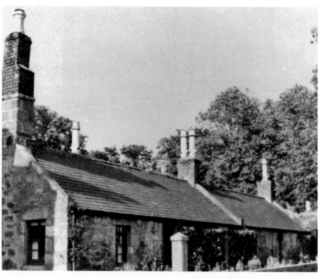

Above left: The construction of Auchtercrag in 1896.

Above right: Annie Watson's cottage. It originally had a thatched roof, hence the 'lang lum'.

Below: Ellon Gordon Hospital, originally a fever hospital but later the maternity hospital for the wider Ellon area. In the 1970s it became the clubhouse for McDonald Golf Club.

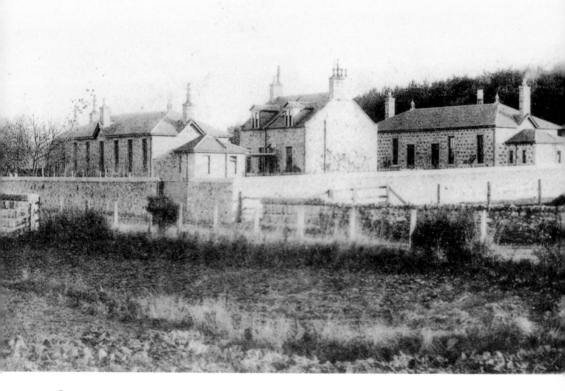

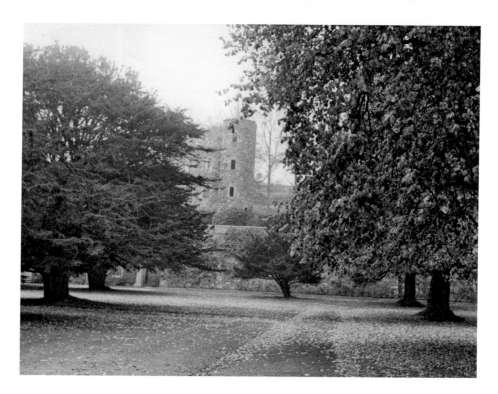

Above: Original Ellon Castle from the walled garden, 1900s.

Below: Gardeners working in Ellon Castle walled garden in the 1900s.

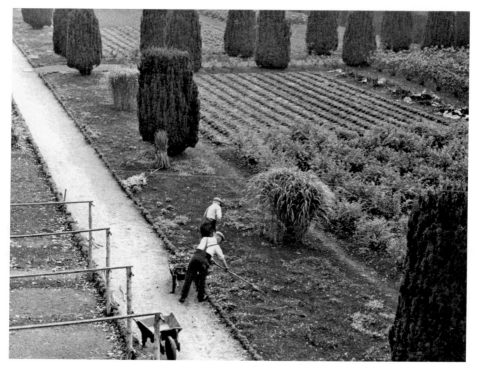

Above: The Poorhouse, built in 1864. It was latterly Ythanvale Eventide Home and was demolished in 1985.

Below: The Mart in 1980 at the junction of Station Road and Hospital Road.

CHAPTER 10

Just Folk

The spirit of the town was, and is still, generated by the townsfolk and many are shown in this chapter. Of the worthy citizens depicted there are people as diverse as merchants, a town crier, tradesmen and even a royal physician!

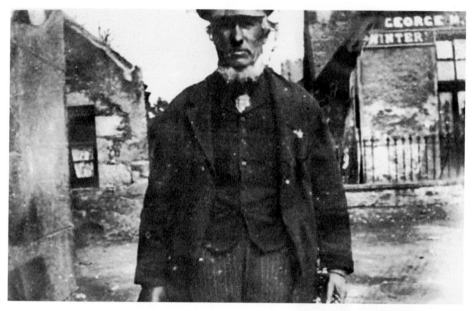

Right: Bathing Belles on holiday at Cruden Bay beach in the 1920s.

Below: Francis Allan, Ellon Town crier in 1910. He was also a tailor, beadle, bellringer, barber and gravedigger.

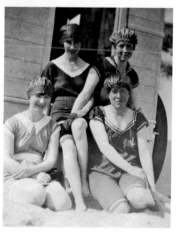

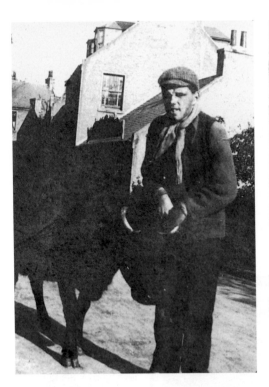

Above left: Revd Dunnett's cow being taken for a walk in the early 1900s.

Above right: Annie Wyness, mother of Bill Forbes, at the turn of the century.

Below: The committee set up to raise money to build Ellon Victoria Hall, around 1900.

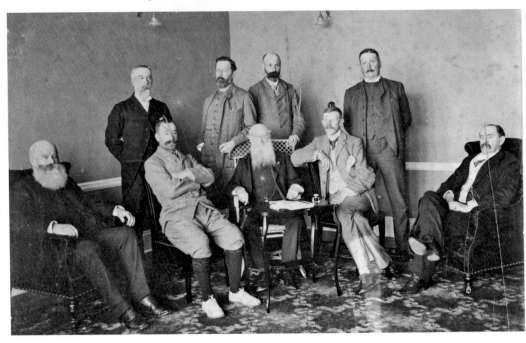

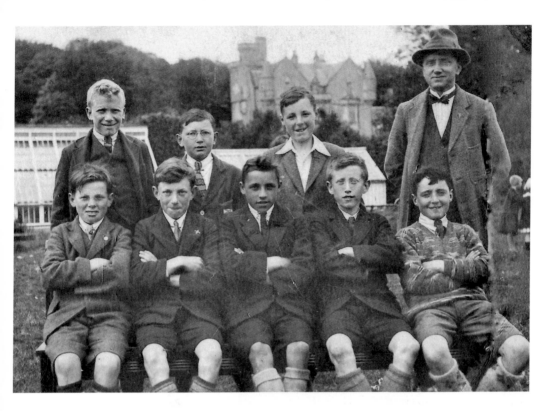

Above: An early photograph of a group of young boys in front of Ellon Castle.

Below left: Dr Andrew Fowler. During the First World War he was medical officer at the Gordon Barracks in Aberdeen.

Below right: Tom Fowler and his grandfather Dr Andrew Fowler in 1918.

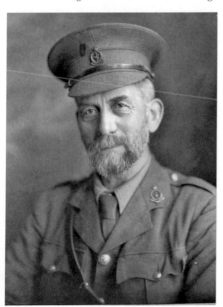

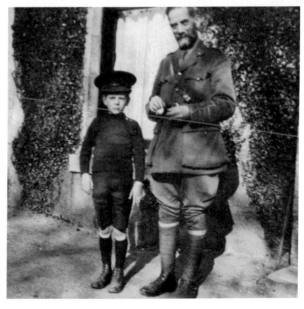

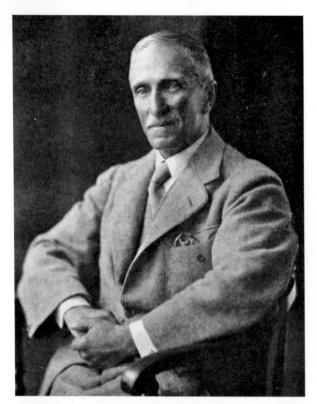

Left: Sir James McDonald of Rhodesia. James emigrated to South Africa as a young man and in time supervised the mines and cattle ranches for Cecil John Rhodes. He presented McDonald Park to the Burgh of Ellon in 1928 in memory of his parents.

Below: Arthur Gordon, owner of Ellon Castle, seated on the right, early 1900s.

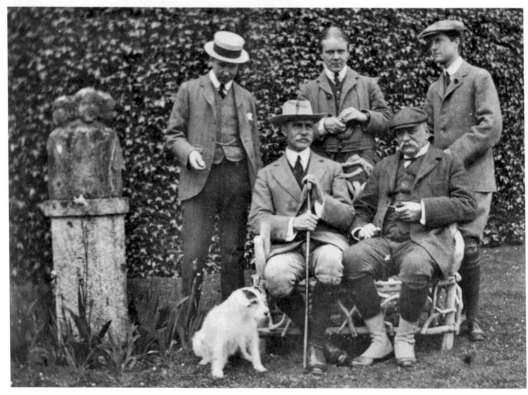

Above: Grandchildren of Sir James Reid, physician to Queen Victoria. From left to right: Peter John Ingrams, Sandy Reid, Leonard Ingrams, Susan Reid, Delia Reid, Rupert Ingrams, Richard Ingrams.

Below left: Sir Edward Reid, Ellon Castle, admiring the champion Shorthorn bull owned by Mr J. N. Reid of Cromleybank at Ellon Show in the 1950s.

Below right: George Bremner, gamekeeper at Ellon Castle Estate, with catch from the River Ythan in March, 1943.

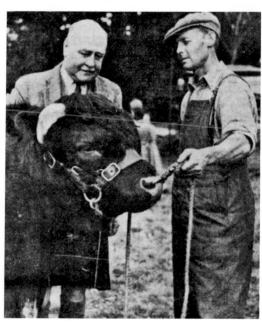

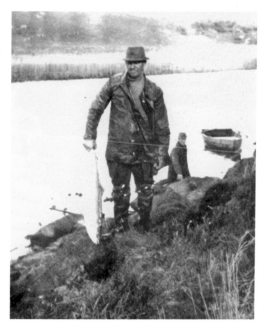

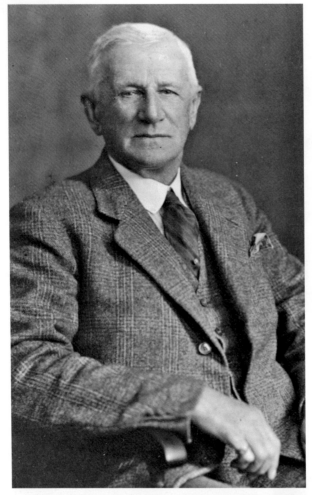

In the year 1899, Mr Thomas Garland (seen left) who had the tenancy of Ardlethen Farm, was asked by the Aberdeen police to join a group of others in a search for escaped prisoner John Grant (pictured below right) who was terrorising the local crofters. Mr Garland found him behind a dyke and as the escaped prisoner reached for his gun, Mr Garland shot him through the foot. 'Thank God you shot me first', said the escapee, 'as I was going to shoot you through the head'. John Grant was given three years in prison. Mr Garland visited him there and when he was released, Mr Garland paid for his passage to Australia. There he did well and trained as a silversmith. He sent Mr Garland the beautiful silver cup, shown in the photograph below left, held by Leonard Garland, grandson of Thomas.

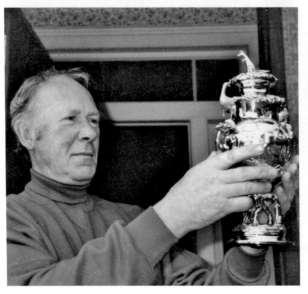

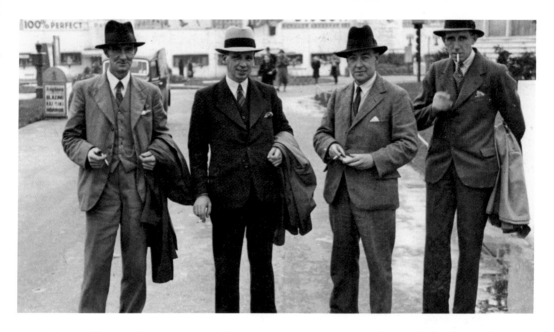

Above: Ellon gentlemen at an exhibition in Glasgow in 1930s. They include Alex Park, Jimmy Ross and Alex Davidson.

Below left: Baby Jimmy with his mother, Christine Mutch (*née* Watson), grandmother Mary E. B. Watson (*née* Oliphant) and great-grandmother Christian Oliphant.

Below right: Andy Robertson's grandparents, Mr and Mrs Forrest, 1900s.

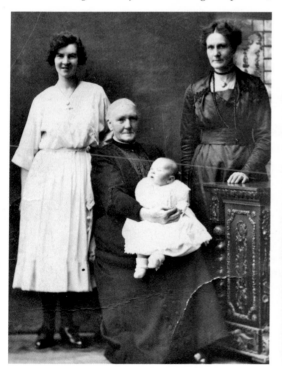

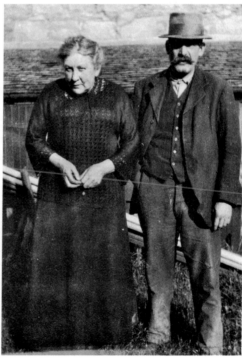

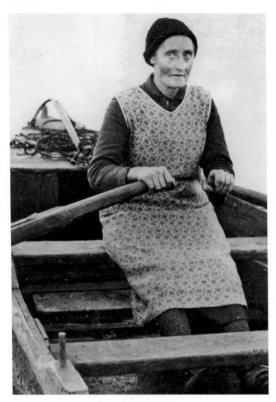

Left: Boatie Mary (Pirie) of Fechil in the 1940s.

Below: Boatie Tam, who was Boatie Mary's son, crossing the Ythan with his shopping at Boat of Fechil.

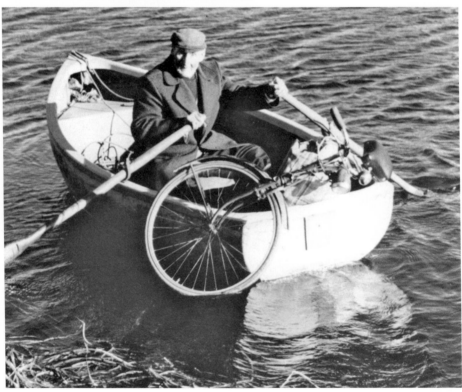

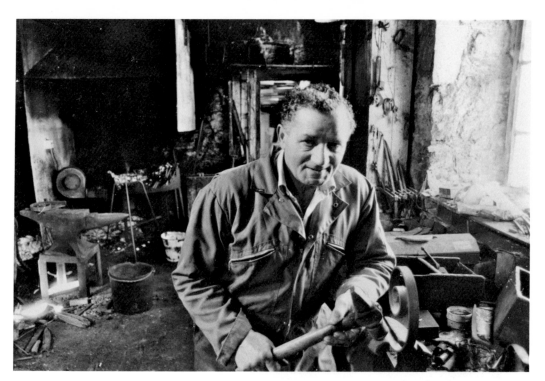

Above: Bill Burnett, local blacksmith for forty years, in the smiddy in the 1970s.

Right: Neil Ross, founder of Neil Ross Motors. In 1917 he opened a cycle shop, which was the start of a family business that grew and became one of the largest employers in Ellon.

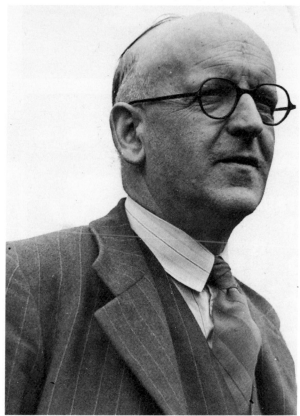

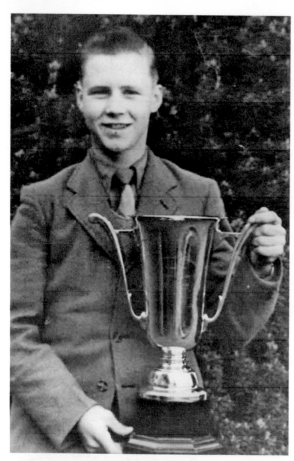

Left: Maurice Moir, Scottish Boys'
Golf Match-Play Champion, 1954.

Below: Angus Moir (unrelated to
Maurice Moir), Scottish Amateur Golf
Champion in 1984.

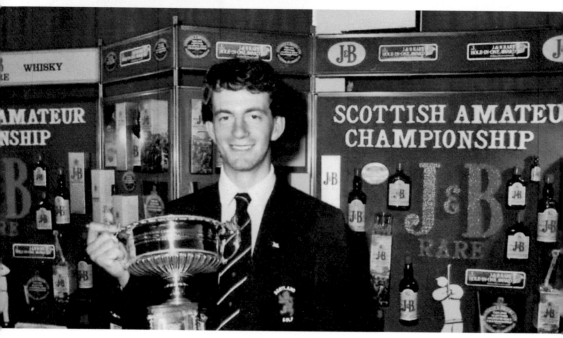

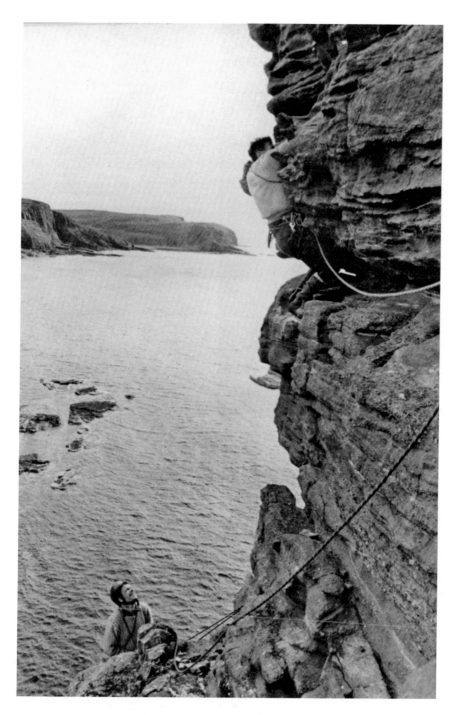

Dr Tom Patey climbing Am Buchaille. Dr Patey was the son of the rector of St Mary's, Revd Thomas Patey. Dr Patey was a distinguished climber and was killed in a climbing accident in the west of Scotland in 1970.

Left: Sandy Mortimer, who lived to be 103. He was awarded the Military Medal during the First World War while serving in a trench mortar company in France. He also received the Legion D'Honneur from the French Consul General to Scotland.

Below: Chrissie Cooper, 105 in 1996, was Ellon's oldest citizen at the time. Cooper's Court is named after her.

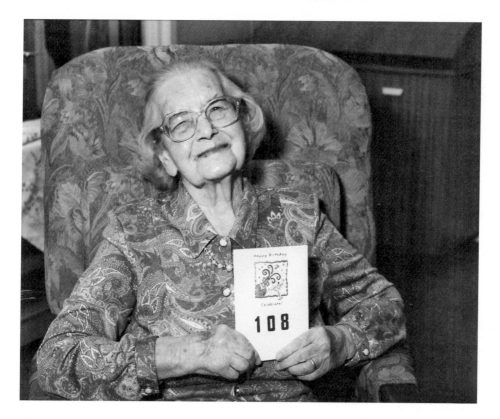

Above: Lizzie Angus celebrating her 108th Birthday in Ythanvale Home in 2000.

Below: Elizabeth Harrison celebrating her 101st birthday with her daughter Barbara Campbell in 2002.

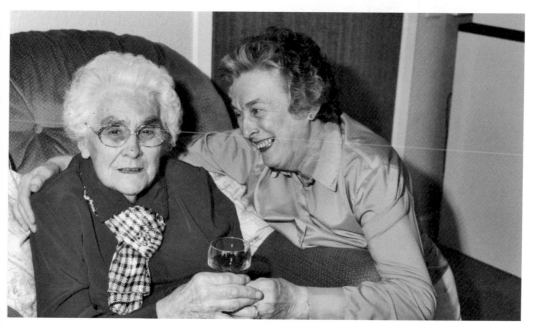

Above: Margaret Moir, who for many years ran a monkey sanctuary at her home.

Left: Lynne Gilbert, from the Ellon Branch of the Cats' Protection League, with Snowball. Lynne has been Branch Co-ordinator for the last twenty years.

Right: Isobel Mutch, teacher, writer, historian and poet.

Below: Fred Watson performing 'Holy Willie's Prayer' at Ellon Rotary Club's Burn's Supper in January 2002.

Left: Jimmy Greig, MBE, beside the War Memorial. Jimmy was for many years Chairman of Ellon Royal British Legion.

Below: Sammy Middler, left, who had been hallkeeper at Victoria Hall in the 1970s, being presented with his hallkeeper's hat by Bill Jolly in April 2001. The hat had been found recently after many years.

Above: Eric Farr, university lecturer, inventor, high standard player and coach of squash, badminton and golf. Many accomplished sporting youngsters owe their development to him.

Right: Bob Davis, local naturalist.

Above left: Ken Gill, local vet for thirty-five years.

Below left: Valerie Duncan and a 'friend' at Ellon Show, 1955/56.